Mosaics

To Barry and David

For UK orders: please contact Bookpoint Ltd,
130 Milton Park, Abingdon, Oxon OX14 4SB.
Telephone: (44) 01235 827720, Fax: (44) 01235 400454.
Lines are open from 9.00-18.00, Monday to Saturday,
with a 24-hour message answering service.
Email address: orders@bookpoint.co.uk

For U.S.A. order enquiries: please contact
McGraw-Hill Customer Services, P.O. Box 545, Blacklick,
OH 43004-0545, U.S.A.
Telephone: 1-800-722-4726. Fax: 1-614-755-5645.

For Canada order enquiries: please contact
McGraw-Hill Ryerson Ltd., 300 Water St, Whitby,
Ontario L1N 9B6, Canada.
Telephone: 905 430 5000. Fax: 905 430 5020.

Long renowned as the authoritative source for self-guided learning –
with more than 30 million copies sold worldwide – the *Teach Yourself*
series includes over 300 titles in the fields of languages, crafts,
hobbies, business and education.

British Library Cataloguing in Publication Data
A catalogue record for this title is available from The British Library

Library of Congress Catalog Card Number: On file

First published in UK 2001 by Hodder Headline Plc.,
338 Euston Road, London NW1 3BH

First published in US 2001 by Contemporary Books,
A Division of The McGraw-Hill Companies,
4255 West Touhy Avenue, Lincolnwood (Chicago),
Illinois 60712-1975 U.S.A.

The 'Teach Yourself' name and logo are rgistered trade marks of
Hodder & Stoughton Ltd.

Cover photo from Steve Tanner
Typeset by Dorchester Typesetting Group Ltd.
Printed in Dubai, U.A.E. for Hodder & Stoughton Educational,
a division of Hodder Headline Plc, 338 Euston Road,
London NW1 3BH.

Impression number 10 9 8 7 6 5 4 3 2 1
Year 2007 2006 2005 2004 2003 2002 2001

Mosaics

Jane McMorland Hunter

With Louise Carpenter

TEACH YOURSELF BOOKS

Contents

Introduction 1

1 Workspace 3
2 Tesserae 5
3 Tools 15
4 Bases 19
5 Adhesives 25
6 Grouts 30
7 Techniques 33
8 Projects 44
9 History 79
10 Design and inspiration 94

Glossary 108

Useful information 110

Suppliers 112

Index 115

Acknowledgements

My first thanks must go to my agent, Teresa Chris, for her continued enthusiasm and support. Helen Green, my editor at Hodder has looked after me beautifully and has always managed to make me feel as if I'm her most important author! I am indebted to Louise Crathorne and Lee May Lim for their work on the production and design of the book. Paul Honor has offered invaluable advice on the practical front and has managed to avert one or two minor catastrophes! For their general help and support I would like to thank Julie Apps, Sara Drake, Sue Dunster, Mark Hammett, Rachel Max, Karin Scherer and Louise Simson. Steve Tanner must be singled out with special thanks for the brilliant photographs and Robin Piguet must be thanked for providing the lolly stick. Barry Delves and David Piachaud have, as ever, provided much-needed moral support. Again, my greatest thanks must go to Louise Carpenter who has managed to convert my ungrammatical scrawl into coherent text, more importantly, she has given me friendship and support for which I am deeply grateful.

Safety

It should be emphasized that, while mosaic-making is enjoyable and relatively simple, it is not hazard-free. Particular care should be taken when cutting tesserae. Chips of glass can fly off at all angles, however careful you are, and goggles must therefore be worn at all times to protect your eyes. Shoes should be kept on in case you step on splinters. And finally, do keep pets and small children safely out of the way to prevent accidents both to them and to your work.

Protecting the Environment

Although it is tempting and sometimes appropriate to use objects that nature provides, it must be remembered that most of these probably belong to someone. This particularly applies to pebbly beaches which more often than not are conservation areas. It is always a wise precaution to ask permission before taking something and, if asked for, it will almost certainly be given.

Introduction

Traditionally the tesserae which make up the mosaics of ancient Greece and Rome were small rectangular pieces of opaque glass. Now objects from around the world can be combined to make beautiful and intricate designs. Shells and pebbles, glass beads, buttons and even brass, gold and silver can be used effectively alongside the traditional tiles. Broken china can also create wonderful designs making mosaics a perfect way to recycle old, chipped and unwanted pieces!

This book describes simply and clearly how to make mosaics. Chapters cover the main techniques involved in this and each method is explained in basic terms so that complete beginners can easily master the craft. More advanced ideas are included for those already proficient in the techniques and useful hints and tips are given throughout. Each stage is illustrated making the instructions easy to follow. A chapter is included on the tools and materials that you will need and a list of suppliers will tell you where you can get hold of them.

The worldwide history of mosaics is looked at in some detail. This is not intended to be a historical textbook, but giving some background can help to put the designs into context and bring ancient mosaics to life.

The chapter on design and inspiration is intended to enable readers to create their own mosaics. It offers advice on how to achieve specific effects and how to use colour and supplies detailed information on the different properties and uses of various tesserae.

There is a section covering projects which are all simple to make and require virtually no specialist equipment. These draw inspiration from a wide variety of sources and each one has step-by-step instructions and clear illustrations to keep everything as straightforward as possible.

Finally, books to use for inspiration and places of interest to visit are listed. The scope for using the Internet is also described and a comprehensive list of suppliers worldwide is provided.

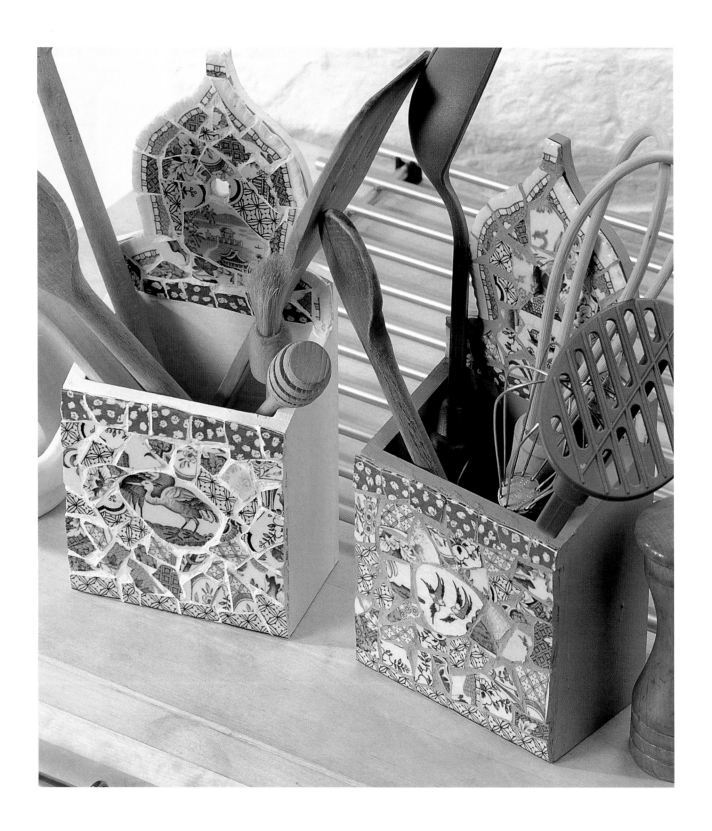

Workspace

The amount of space you need for making mosaics obviously depends to a great extent on the type and size of mosaic you are making. Many small projects can easily be made on a small table, but it is much easier if you have a room where you can safely leave your work undisturbed. This is important because most mosaics have to be left to dry or set and this process usually takes about a week. At this stage it is particularly important to keep pets and children away from your work.

An important factor to bear in mind is that making mosaics is a messy business. On the whole it is a mess that can be cleared up easily, but at any stage you are liable to have broken chips of china, tubes of glue and bowls of grout all lying around.

The first consideration therefore is that your chosen workspace needs to be easy to clean. You must be able to sweep or vacuum the floor as mosaic chips and shards of glass or pottery will fly all over the place. If the floor of your workspace is carpeted, it is a good idea to spread an old sheet over it. This will also make life easier if you drop precious tesserae while you are working. Most stages of mosaic-making can get dusty and it is best to get into the habit of sweeping up thoroughly when you stop at the end of each day.

You will probably complete any preparatory drawing before you start making the mosaic but if you have enough space, allocate an area of your workshop to

drawing. All your papers, pencils, crayons and colours can be kept there away from the glues and grouts.

If you do not have the luxury of unlimited space, your workbench or table will, by turns, have to accommodate the designing, glueing, grouting and cleaning of your mosaic. This is perfectly all right, but you must make sure it is a comfortable height to work at. If you find yourself standing up and stretching in agony every half hour then something needs to be adjusted. Many people like making mosaics standing up. With large projects you should be able to walk around the board or surface. If you are using a table with a delicate surface, always cover it with a thick layer of newspaper first.

Even after making a single mosaic, you will find you need a surprising amount of storage space for your tools and tesserae. Ideally the tesserae should be stored in glass jars or clearly labelled boxes on sturdy shelves.

It is very helpful to be able to see all your tesserae at once, particularly at the designing stage. If your tesserae are all hidden away in cardboard boxes, it is very easy to forget what you have got. Adhesives, cements and grouts should all be kept in a separate place where there is no danger of them getting wet. Tools must also be stored in a completely dry area to ensure against rust.

Lighting is also another important consideration. Natural light is obviously the best and most pleasant to work in, but daylight bulbs are available which provide a good alternative. Good lighting is essential while constructing the mosaic but remember to take into account what sort of lighting the piece will be

subjected to in its final position – it may look quite different in different light. If you are doing particularly detailed work an anglepoise or spotlight can make a big difference.

Water is useful to have on hand, but not essential. The cleaning stage is often best done out of doors and grouts and cements can be easier to mix outside.

One word of warning – be very careful what you pour down the drain. Cement can very easily block pipes totally. If in any doubt wrap the unused adhesive or grout in newspaper and throw it away with your household rubbish.

■ For most people a kitchen will be perfectly suitable to make mosaics in.

Tesserae

Collecting suitable tesserae for your project is probably the most important activity you will undertake in determining the look of your finished piece. It is also great fun. If you have a particular project in mind, you may know exactly what tesserae you require and therefore need only to purchase them directly from the relevant shop. But perhaps you will then find yourself with a few bits left over and they might spark off another project. It is always a good idea to be on the lookout for interesting or inspiring objects which could be used, either whole or broken, in a mosaic. These might include buttons, shells, pieces of china or even bottle tops. Traditionally the word tesserae conjures up small rectangles of stone or glass, but nowadays an enormous range of raw materials can be used to make mosaics.

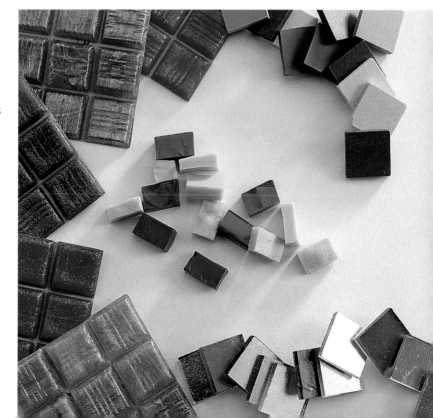

■ Traditional tesserae: smalti, vitreous glass tile and matt ceramic tiles.

Commercially produced pieces can be purchased from specialist craft or tile shops but, depending on the effect you wish to create, this can prove expensive. Charity shops, jumble sales, flea markets and car boot sales can all yield wonderful things for comparatively little money. In fact a chance buy can often be the inspiration for an entire mosaic.

Friends who break things can also be a valuable source of tesserae! Mosaics, like patchwork quilts, are an ideal way of preserving small or broken parts of an original which had sentimental value. The much-loved plate you inherited from your grandmother, though broken, can be kept for ever in all its pieces as part of a mosaic. Holiday souvenirs, which may not look quite so good when you get them home, can be broken up and used to create a memento of an enjoyable time.

Try to collect as many varied objects as possible – you never know what you may need for your next project. Sort your tesserae and store them as tidily as possible – glass jars, small baskets and Tupperware all make ideal containers. This way you will be able to see at a glance what you have got.

Finally, do not be afraid to play with your tesserae. The more you handle and study the individual pieces, the more you will be aware of their potential. Also laying pieces out at random may provide new inspiration for a project.

Below I have listed the main types of tesserae and have tried to give a rough indication of their uses and requirements. Bear in mind that this list is by no means comprehensive and is designed only to provide you with the basic information you will need in order to start experimenting with your own ideas.

Smalti

These tesserae are made of specially treated glass and have been used in mosaics for over two thousand years. They have always been one of the most popular types of pieces because of their brilliance and beautiful reflective qualities. The Romans used smalti in the first century AD, particularly blues and greens, to provide colour variations in mosaics which were mostly made up of pieces of stone. The word smalti means 'melt' in the Roman language and that is how the glass is treated. The original glass is made up of a vitrifier which forms the glass and fluxes which enable it to flow freely. The vitrifier is silica (sand or crushed pebbles) and the fluxes are sodium or potassium carbonate. To this mixture stabilizing agents such as magnesium or lead are added and then the all-important and closely guarded secret – the colouring agents. The formulae for these were, until recently, handed down with the utmost secrecy through the generations of the families who made smalti. Even now they are only produced in Venice and the colour recipes for the five thousand different colours available remain shrouded in mystery.

The glass mixture is heated using a process called fusion which consists of carefully monitored control of time and temperature. This is the vitally important stage which controls the colour, brilliance and opacity of the glass. The Romans usually created fairly subtle colours but in the fifteenth century greater amounts of lead were added which made the colours brighter and, indirectly, had the advantage of making the glass easier to cut. Metallic irons or combinations of oxides are usually used to colour the glass, for example, chrome produces a yellowish green and selenium or cadmium produce reds and pinks.

Once melted, the liquid glass is then poured onto a metal sheet using a casa or long-handled spoon. The glass can be poured into rectangular moulds or more traditionally ladled onto the metal sheet to form pizze or irregular round plates. It is then slowly cooled using a process called annealing during which the temperature is carefully monitored so the glass does not cool too quickly.

Once the pizze or slabs have cooled they are cut into small rectangles, usually ⅜" × ½" × ¼" (10 mm × 15 mm × 7 mm). The bricks are usually used with the

cut faces uppermost as these are the most reflective. Tiny air bubbles can frequently be seen – these are not a fault in the glass but help to add more interest and variation to the surface. Some mosaicists do not use the curved pieces from the edge of the pizze, but these can, if used carefully, provide even more variation to the surface.

Normally smalti are not grouted as the grout can get into the air-holes and spoil the reflective qualities of the piece. The individual bricks are pushed three-quarters of the way into the mortar and are therefore firmly held in place while standing slightly apart from the surrounding smalti. This technique is known as self-grouting. It is also useful for uneven objects such as shells, beads and pebbles.

As the individual smalti are irregular sizes they are not usually suitable for floors or any surfaces which need to be particularly level.

Smalti can be bought in uncut slabs or ready-cut in single colour or mixed bags. Very roughly, one square foot (30 cm^2) needs three pounds (1.35 kg) of smalti.

Gold and silver smalti

Gold and silver smalti have been used in mosaics since the fourth century and reached the height of their popularity under the Byzantines who loved their reflective qualities.

They are made with real gold or silver leaf which is sandwiched within the tile. The precious metal is placed on a thick layer of coloured glass and then sealed in place with a thin layer of plain glass. Gold tiles are usually made on a base of dark green glass and silver on dark blue. These background colours make the shades of the metal richer and this can be further varied by using different coloured metals. The actual layer of metal is incredibly thin – usually fifteen micrometres – i.e. 0.15 thousandths of a millimetre. One cubic centimetre of gold will cover sixty-four square feet (six square metres), but although only a small amount of the precious metal is used the smalti

are still relatively expensive as they are hard to produce. Some are made with a rippled surface which is uneven and bubbly and therefore even more reflective.

The Byzantines used huge areas of these tiles as the background to many of their religious mosaics, but in most cases a little goes a long way – a few gold or silver smalti, strategically placed, can transform an otherwise dull and lifeless piece.

Smalti Filati

A special technique was used to produce the tiny pieces which were used in the miniature mosaics popular in the Vatican in the eighteenth century.

A piece of glass was heated over a flame and then pulled into a long thread or rod using tweezers. These rods were then allowed to cool slowly and were finally cut into tiny pieces, often only one millimetre in diameter.

Smalti filati can be obtained today, but tend to be expensive and are much too fiddly for most people's taste.

Vitreous glass

This is probably the most commonly used type of tesserae. The pieces are easily available and usually (depending on the colour) cheaper than smalti. They are also strong, weather-resistant and easy to cut using nippers. They usually come mounted on paper sheets consisting of 15 × 15 tiles, each tile being ¾" square (2 cm^2). This paper can easily be soaked away using warm water and the tiles should then be rinsed to remove any residue of the adhesive. The tiles should be laid out to dry and are then most easily stored in glass jars where you can see the different colours.

The tiles are also available in mixed boxes (55 lb or 25 kg) of 'scrap'. Many shops will also sell smaller mixed bags. These usually work out considerably

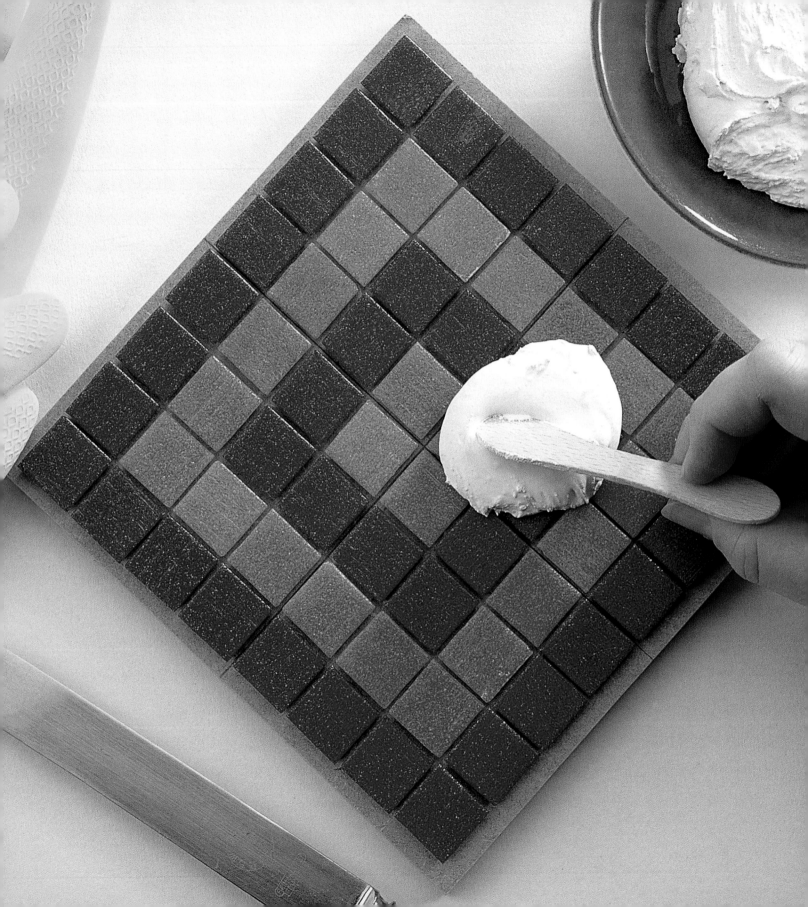

cheaper than the sheets and are often worth buying as they can contain unusual colours not readily available. However, you must also take into account that many of the tiles in the bag may be broken and you may also end up with colours you do not want. The most common use for these tiles is for surrounding and filling swimming-pools and thus the most readily available colours are various shades of blue. Most other colours are available but some can be very expensive. The sheets are divided into series with series 1 being the cheapest and consisting of pale shades. They then work up to series 4 which are the brightest (and most expensive) with metallic streaks running through them. Due to its chemical make-up, candy pink is on its own in series 5. The range of colours can vary so if you need a particular shade, always make sure you buy enough at the beginning.

Each tile has a smooth upper surface and a ridged lower surface. This is to provide a better grip to the adhesive, but for decorative purposes the tiles can be used either way up as long as you make sure they are firmly fixed in place. Used the correct way up, the tiles produce a flat, firm surface, but unless you plan your design carefully the end result can look boring. Graceful sweeping curves look particularly good over large areas and geometric patterns can be very effective. As a rough guideline, you should allow twenty per cent extra for wastage when cutting designs.

With a little practice, the vitreous glass tiles are easy to cut. Curves can be achieved by nipping off small pieces at a time (see page 17). One thing to be very careful of are the glass splinters – do not be tempted to push them aside with your hands as they can be very sharp. Always use a brush and wear protective goggles.

Ceramic mosaic tiles

These are usually unglazed tiles which are a uniform colour throughout. Cinca are made in Portugal and come in a range of about twenty-five colours, usually muted shades of grey, brown, pink, terracotta, black

■ Ceramic tesserae: plain and patterned household tiles and crockery.

and white. The individual tiles are ¾" or 1" square (2 cm² or 2.5 cm²) and come on sheets of 14 × 14 tiles. They can be soaked off the paper in the same way as vitreous glass tiles, but care should be taken that the tiles do not then stick to each other as the adhesive used is much stronger and therefore harder to wash off. The tiles are the same on both sides and have straight edges. They are easy to cut with nippers or tile cutters, although as before care should be taken with shards of pottery.

The unglazed tiles are non-reflective and mosaics made up entirely of them are usually very gentle and restful to look at. If they are used in conjunction with reflective tesserae such as vitreous glass the design in the glass will stand out clearly while the cinca will seem to recede into the background.

Cinca are particularly useful for copying Roman designs or creating a Roman effect as the colour range is very similar.

Glazed, shiny tiles are also available in the same format and can be used either on their own or in conjunction with the matt tiles to create interesting effects.

Household tiles

Ordinary household tiles are an invaluable source of mosaic tesserae. Large pieces or even whole tiles can be used to fill in expanses of background. Household tiles come in a limitless range of colours and designs and can be relatively cheap. Many tile shops sell old stock or left-over tiles very cheaply and interesting examples can also be found at jumble sales and boot fairs.

Household tiles are usually easy to cut with nippers but always try and test a tile before buying a large quantity as some are apt to crumble or break unevenly depending on the strength of the tile and the type of glaze. One thing to be wary of is that not all tiles are frostproof. This obviously will not matter if your mosaic is for indoors, but it may matter if you intend to keep the finished piece outside. It may seem silly to worry about extra cracks in a piece which is already made up of broken china, but cracks caused by frost will look different from the other joins and may spoil the piece.

China

China is probably the most versatile type of tessera. Anything can be used, from the finest porcelain statue to a heavy earthenware bowl. Always be on the lookout for interesting pieces: handles and spouts can be great fun to work with and lids can provide good centrepieces. Not all china is frostproof and most is not usually strong enough for floors but other than that it can be used anywhere and anyhow. An important fact to remember is that the strength of a piece of china depends on what temperature it was fired to, not how thick it is. Fine porcelain is often much stronger than thick earthenware.

It is worth collecting as much china as possible and then sorting it into types. This way you will be able to see what you have got and plan accordingly. It can be very frustrating to find you have used up all you have of a certain pattern when you are half-way through the mosaic.

Plain white china may seem too boring to include in a mosaic, but in fact it can be very useful. It is an ideal way of splitting up areas of colour and can also be used to emphasize a design – too many patterned tessera together can end up looking a muddle. Beware that not all china is the same thickness and, odd as it may sound, not all white china is the same shade of white.

Plain-coloured china can have the same uses as white china but it can also alter the feel of the design. Flowery tesserae surrounded by plain white china will look fine and delicate whereas if a border of dark blue is used, the pattern will look richer and bolder. You can also emphasize a colour in the pattern by echoing it in a plain border. Yellow flowers or designs will stand out more if surrounded by a border of plain yellow pieces.

Patterned china is probably the most fun to use and collect. Flowers, scenes and geometric patterns are obviously useful but look out for writing on china – hallmarks underneath individual pieces and souvernirs with place names on them can look quite eye-catching on a mosaic. Blue and white patterns such as the famous willow pattern are lovely and it is amazing what variations you can get just within that one pattern. Older pieces tend to have a softer colouring whereas new pieces are often much brighter.

Antique china can be very beautiful, but unless it is already broken it is usually too expensive to use for mosaics. Old china washed up along the sea shore or river banks will have been softened by the water, but old porcelain generally tends to be brittle and can be

very difficult to cut. Earthenware or lower fired china is usually much easier to cut accurately.

Lustreware is not so common now but was extremely popular in the 1930s and 1940s. It is coated with a special glaze which gives a sparkle unlike any other kind of china. Small pieces can be used to brighten a design or whole areas can be infilled using lustreware to give a rich sheen.

Flower pots are very easy to cut as they are usually made of low-fired terracotta clay. Again, be cautious as they will probably not be frostproof and some may actually be porous and suck up water if they get wet.

A final point to mention about china generally is about rims and edges. Rims of plates and cup and edges of tiles tend to slope away. This can cause problems if the pieces are used within a design as the edges will be lower than the rest of the surface and may come below the level of the grout. However, these pieces can be invaluable for edging mosaics so it is always worth sorting them out and keeping them separate from the other pieces.

Shells

Fabulous shells can be bought from specialist shops – particularly in seaside towns where many tourist shops will stock exotic examples from all around the world. Even ordinary shells picked up off the beach can be very effective. If you want them to glisten as if they are still wet it is worth varnishing the shells before you fix them in the grout – it is much more difficult to varnish them once they are in place. Shells can be used either way up but they should always be firmly pressed into the mortar as they are delicate and the mortar will fill the crevices and give them extra strength. Mother-of-pearl, which is the beautiful lining from pearl oysters, can be carefully cut and used in mosaics. Areas of mosaic with shells and other unevenly shaped tesserae should not be grouted as they will be extremely difficult to clean afterwards. As with smalti the shells should be pushed three-quarters of the way into the the mortar which will then provide the grout around the piece.

Pebbles

The earliest floor mosaics were made of pebbles and these can be used in mosaics of all types and sizes to great effect. In the Alhambra in Spain they line the gardens in the Generalife. If you want a particular colour it may be worth buying pebbles from a builder's merchant or garden centre, but most can usually be found by simply walking along a beach or riverbank.

■ Unusual tesserae: shells, pebbles, glass nuggets, china and wooden beads and buttons.

It is here that a very important point must be made – pebbles on riverbanks or beaches nearly always belong to someone. You may have the right to walk on them, but you do not necessarily have the right to take them away. Even if the landowner is only the local council, legally you must seek permission before removing the pebbles. It is very unlikely that anyone would object on a small scale, but it is often hard to tell whether a beach is part of a conservation site or an area of unwanted shingle which has shifted and accumulated along the coast. The motto is always get permission first – creating mosaics is a wonderful pastime, but not if it is at the expense of the natural landscape.

Once you have collected your pebbles it is worth sorting them into size and, more importantly, colour. A mass of pebbles of the same colour will give a greater intensity of that colour than individual pebbles can. Quite subtle colours can appear surprisingly striking when arranged in groups.

When choosing pebbles make sure they are made of hard stone. Flint, quartz, granite and limestone are the best. If in doubt, hit the pebble hard with a hammer. Soft rocks will crumble away. Old bricks should also be avoided. They may have been worn smooth to look like attractive pebbles but they are not hardwearing enough to be used as part of a mosaic. Like shells, pebbles should be firmly embedded in the mortar and not grouted afterwards.

Stone

Many Roman mosaics were made of natural stone cut into cubes similar to smalti.

As with pebbles the strength of the stone is very important. Soft stones such as slate can be separated into layers and used to create interesting effects but the best stone, really, for mosaics is marble. It comes in a great range of natural colours and patterns, the colours being influenced by the minerals in the surrounding earth. White marble is most commonly found in Carrera and the Middle East, pink in Verona and yellow in the area around Siena.

Marble is not easy to cut but can be bought in cubes which are cut commercially using a wet saw. They are available in single colours on a webbed backing, but this can be hard to get off so if possible buy the cubes loose. The cubes usually have a polished face and matt surrounds where the stone has been cut. Either can be used. If the cubes are further cut using nippers, a rough, crystaline surface may result which will reflect light very well. Marble can be grouted or sunk into the mortar depending on the effect you wish to create. It may need to be sealed if it is to be used out of doors or near a pool as some marble is porous.

Minerals and semi-precious stones

These may seem very expensive but, as with gold and silver smalti, a little goes a long way. They would be unsuitable for a large mosaic but on small items pieces of stones such as turquoise or lapis lazuli can look very beautiful.

Mirror

This can create an equally interesting effect, both by brightening the mosaic and creating interesting reflections. Mirror is usually cut with a glass cutter or can be bought ready-cut. It is safest to seal the back with a sealant before sticking the pieces into the mortar to prevent the silvering deteriorating.

Other ideas for tesserae

Listed above are the most common traditional types of tesserae but, as stressed earlier, almost anything can be used. Glass beads, ceramic beads, buttons and bottle

caps will all add sparkle to your mosaic. Seeds and nuts, if treated, will last well and, as long as the mosaic does not have to withstand rough treatment, perishable objects can be used such as card, paper and feathers. Before you embark on a project, decide how hard-wearing it needs to be. As long as the tesserae fulfil your requirements you can use almost anything you like.

Estimating how many tesserae you need

One of the most difficult parts of making a mosaic is estimating how many tesserae you will need. It is always safer to buy more than you think you will need in case pieces break awkwardly, but obviously you do not want to end up with large amounts of a colour or design you are unlikely to use again. As mentioned earlier, with vitreous glass tesserae you should allow twenty per cent wastage, but with tiles, ceramics or mixed media it is not always possible to be so exact. If you multiply the width by the height of the finished piece, you will then be able to calculate the area of the mosaic. From this you will be able to work out roughly what area you will need of each type of tessera. Remember to allow for plate rims, tile edges and particular patterns you may wish to use. Even if you think you have worked the amounts out accurately, always lay all the tesserae out in place before gluing any of them – at this stage mistakes can still be rectified.

■ Seeds and nuts offer a variation to traditional tesserae.

Tools

Do not be put off by all the tools listed on the following pages. Many, such as pencils and plastic bowls, will be things you already have. Other tools can be adapted, such as an old kitchen knife instead of a specialist palette knife. Probably the only things you will need to buy immediately will be a pair of goggles and some nippers for cutting ceramic tesserae.

The tools below are grouped together in the various stages of mosaic-making but many, particularly with gluing and grouting overlap the different techniques.

Designing

It is always worth taking time to plan your mosaic even if you are intending to place the tesserae randomly. If you want you can do an elaborate painting of the proposed design but for most projects some sketching paper and half a dozen crayons or felt tips will suffice. An eraser and ruler are also necessary and graph paper is useful to ensure your diagram is roughly to scale.

If you wish to do geometric designs you will need a set square, protractor, a pair of compasses and possibly a

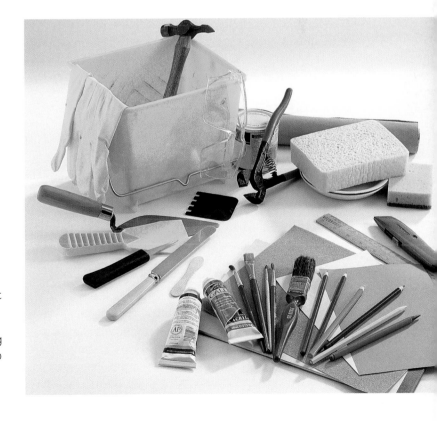

■ Useful tools for mosaic-making: nippers, hammer, drawing equipment, paints and paint brushes, sandpaper and a sharp knife.
■ Left : Intricate tesserae

steel ruler and if you wish to copy designs exactly you will need tracing paper. Carbon paper can also be useful for transferring designs and if you are using glazed ceramics as a base you will need a permanent marker to plan out your design. As you can see, many of the things you will need are already lying around your house – possibly unused since your school days!

Preparing the base

All you need for this stage is a sharp knife or hacksaw blade with which to score the surface so the adhesive will bond to it. The PVA is harmless and can be diluted in almost any container and it can be painted on with anything from a fine paintbrush to a household decorating brush. Obviously the size of your project may dictate what size brush you need. Sandpaper is also necessary at this stage if you are using plywood to smooth the edges. Unless they need to be very smooth, medium grade is fine. Cut ply with the back face uppermost. This will ensure that the exposed side is smooth and any breaking away at the edge of the wood is covered by the mosaic.

Cutting

Tile nippers

Tile nippers may well be the only cutting tool you will ever need, with goggles as essential protection. They look like oddly shaped pliers with cutting blades protruding at right angles to the handles. The cutting edges should be tungsten carbide which is extremely strong and will easily cut most ceramics and glass up to ¾" (2 cm) thick. It is sensible to invest in a fairly good quality pair of nippers as you will use them a great deal and the better ones will last longer and are much more pleasant to use. An important feature to look for is that the nippers should have sprung handles. These will automatically spring open after you have made the cut ready for use again. The top of

the range models have replaceable jaws and compound leverage but this is only really necessary if you are going to cut very hard materials such as stone. Ordinary nippers can be bought at builders' merchants or specialist mosaic shops.

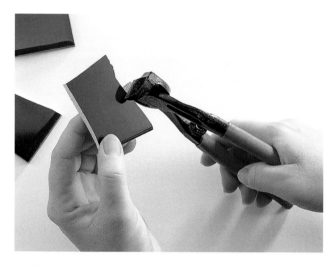

■ Holding the tile nippers correctly makes it very easy to cut the tesserae.

Wearing goggles, hold the tessera firmly in one hand and place the blades of the nippers where you want to make the cut. The cutting edge only needs to cover the edge of the tessera – usually ⅛" (0.3 cm) is sufficient. Hold the nippers at the end of the handles as this gives you much more power. Most handles are indented so you should automatically hold them in the right place. Press the handles together and the tessera should break in two along the line of the blades. If only a small chip breaks off, try placing the nippers slightly further over the tile. With practice you will very soon be able to judge exactly where to place them. When cutting old china or tiles, bear in mind that they may split along a previous crack or line of weakness rather than the line you were aiming for. If you want to cut round a particular motif, cut roughly round it first leaving plenty of space in case the piece breaks awkwardly. Gradually trim the tile to the correct size by nipping away small pieces. If you do

break the motif, don't worry, the pieces can probably be put together when you make the mosaic. Large motifs may need to be broken up anyway unless you particularly want them to stand out from the design.

Square tesserae are easy to cut and usually break exactly along the line of the nippers. As before, place the blades about ⅛" (0.3 cm) over the tessera. As the diagrams below show, it is possible to create curved shapes such as circles very easily. To make concave curves you have to nip away the pieces very carefully in small sections.

As a general rule, always make the cuts as small as possible. It is always possible to cut more away, but it may not be so easy to place pieces back together again.

■ These dotted lines show how square tesserae can be cut into further shapes such as octagons, circles and triangles.

Hammer

An ordinary hammer or rubber mallet is useful for breaking large pieces of china or tiles into more manageable chunks. Before you use this method check that you do not mind how the piece breaks – handles and spouts in particular can be worth preserving intact. Either place the china inside a plastic bag or between several sheets of newspaper. Put on a firm surface and hit fairly hard with the hammer. Remember the sharp edges of the broken pieces may damage the surface you are using so either protect it well or use a surface which does not matter. Paving stones are ideal for this.

Hammer and hardie

These are useful for cutting thick tesserae such as smalti or marble. The hardie or bolster blade is similar to a short wide chisel. Its handle should be firmly mounted into a solid base. Pieces of tree trunk are ideal for this. They can then either be stood on the work surface or grasped between your knees. The hammer is double sided with a sharp edge at each end. Both the hammer and hardie should be tungsten carbide tipped for extra strength. The hardie should be placed so it is completely solid and the tessera held on top of it along the line of the break. Hit that line firmly with the hammer and the piece will neatly break in two. This takes a little practice but once you have mastered the technique it is a very easy way of breaking thick tesserae.

Tile cutters

A huge variety of tile cutters are available from specialist shops but they are all based on the same principle of scoring the surface of the tile and then applying pressure to break it along that line. They are useful if you want to cut long straight lines, but they take a bit of getting used to so practise on some spare tiles first.

Gluing

To a certain extent the tools you will need at this point will vary according to the type and size of mosaic you are making.

Old paint brushes are ideal for buttering PVA onto tesserae and epoxy resin comes with its own plastic spatula for mixing the glue and spreading it. Lolly sticks can be used and cocktail sticks are useful for very small tesserae. Palette knives can come in handy, but frequently an old kitchen knife will do just as well as long as the blade is fairly flexible.

For projects using cement-based adhesive, a trowel can be used to spread the adhesive evenly over the surface. For indoor mosaics you can use a notched trowel which will give the tesserae extra grip but for outdoor mosaics you should use a flat-ended trowel (either square or pointed) as water could get into the grooves in the cement and cause damage if it froze.

For very large areas, a builder's float can be used to spread the cement evenly over the base.

For fine mosaics, tweezers or dentists' tools can be useful for positioning the tesserae in exactly the right place.

Grouting

If you mix your own grout you will need several plastic bowls and a bucket to wash them and your tools in. You will also need a bag for any unused grout – it must never be put down drains as it will block them.

Grout spreaders are smooth flexible tools which allow you to spread the grout in between the tesserae without scratching them. Plastic spatulas and lolly sticks can also be used for this. Once the grout is spread over the mosaic one of the best tools for pushing the grout into the crevices is your fingers. You will find you have much greater control over where the grout goes but beware – always wear rubber gloves as grout is rough and will soon wear away the skin on your fingertips!

A squeegee is useful for grouting large areas. This is a wide rubber flap attached to a wooden handle. You use the rubber flap to push the grout down between the tesserae by wiping it backwards and forwards across the mosaic.

Wooden tools are most useful for removing grout. Specialist tools are available from mosaic shops but pottery tools and even lolly sticks can be used. All these will remove dry grout from the surface of the tesserae without scratching them. Bradawls (or awls) or old dentists' tools are useful for removing grout from small areas as long as you are careful not to damage the tesserae.

Cleaning

Lint-free cloths are useful for cleaning mosaics. These can be anything like old tea towels which do not give off fluff. Non-scratch nylon scourers and stiff bristle brushes will also remove dry grout.

Any type of sponge can be used to remove grout, but the most useful is a tiler's sponge which you will be able to buy from a builders' merchants or tile shop. It is much denser than an ordinary household sponge and this makes it perfect for picking up the fine powders from grout. It is much more efficient at picking up the dust and will not leave smears on the mosaic.

Stubborn pieces of grout can be removed with a diluted solution of hydrochloric acid but the manufacturer's instructions must be closely followed as this is a dangerous substance.

If the mosaic tesserae have lost their shine, clean with a weak solution of liquid floor cleaner using a non-scratch scourer.

Grout sealant can be bought from tile and mosaic shops. It is a clear liquid which is painted on once the grout is completely dry. It can be used on table tops to prevent stains. It can also be used as an alternative to varnish if you want tesserae such as shells or pebbles to stand out.

Bases

The range of bases which can be used for mosaics is enormous. Almost any firm surface can form a base although most will need a simple preparatory treatment. Cars, cookers, rooms and even whole buildings have all been covered with mosaic-work. Once you have started making mosaics you will frequently find yourself looking at a surface and thinking how good it would look decorated with mosaic!

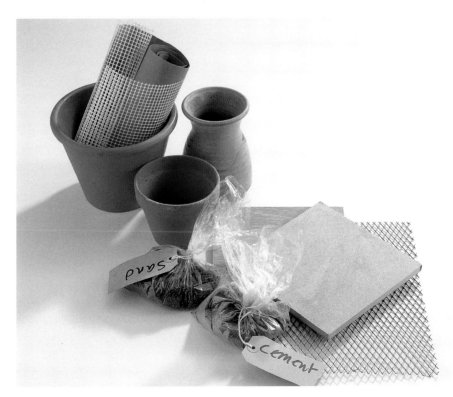

■ A selection of bases which can be used for mosaics: MDF, ply, terracotta, net and ready made objects such as a vase.

These examples are obviously extreme, but many everyday household objects can easily be decorated in this way. Vases, lamps, candlesticks, bowls, mirrors and frames are all suitable. Furniture such as tables, chairs, benches, shelves and fireplace surrounds can easily be transformed into interesting and individual pieces and on a larger scale garden urns, fountains, bath sides, splash backs and doors can all be decorated although these projects are probably not suitable for a complete beginner as working on a large scale involves considerably more planning. If you become really ambitious you can transform your garden patio, decorate a whole room or even build a grotto!

Various considerations are important – firstly your chosen base must be strong enough to support the finished mosaic. This will include the weight of any preparatory base necessary, the tesserae and the grout in between. The surface must also be rigid since any movement would eventually cause the tesserae to chip off. If decorating furniture, you need to ensure that drawers and doors will still open and close properly and for walls you need to allow again for the opening of doors and possibly windows and also for fixed objects such as light switches.

The second consideration to take into account is the choosing of tesserae that match your base and look good on the finished object. Flat or gently curving surfaces are the easiest to decorate. Anything with sharp corners or edges will need to be planned carefully so that your design does not come to an abrupt end. Also beware of trying to improve an unattractive object. If something is an ugly shape in the first place, it is not necessarily going to be transformed into an object of beauty merely by being decorated with a layer of mosaic.

Once you become adept at the technique (and this will happen surprisingly quickly as mosaic-making is very easy) you will be able to tell at a glance what would look good, but for the first project you should ideally choose something fairly simple – the mats on page 74, wall holders on page 65 and table top on page 51 would all

be suitable. Use these to spark off ideas of your own but as a general rule, remember that reasonably small, flat surfaces are the easiest to decorate.

Nearly all surfaces need to be prepared before they can be decorated, but this is usually a fairly simple process. Most mosaics will stick better to a rough surface so, if possible, it is worth scoring the surface of the base. This is especially important for wood or metal and the techniques for this are described below. You should then ensure the surface is clean and completely free of any dust or grease before treating it with a sealant which will allow the adhesive to stick better. Again the individual techniques for different bases are described below, but most surfaces benefit from a layer of PVA, diluted with 50% water which transforms it from an adhesive into a sealant.

Wood

MDF (Medium Density Fibreboard) and plywood are both excellent bases and are used in the majority of projects in this book. Both are cheap and easy to cut into fairly elaborate shapes. MDF is easier to cut, especially if the project involves curves as it has no rough edges. However it is prone to warping or bowing if exposed to damp or too much pressure and must be sealed on all faces. Ply is harder to cut into elaborate shapes, but tends to be more rigid. The base should be thick enough to support the mosaic – ½" (1.25 cm) is usually enough for shapes up to 36" square (90 cm), ¾" (2 cm) after that. The surface onto which the tesserae will be stuck should be roughened using a sharp knife, stone or hacksaw blade. The scratches need not be very deep, just enough to provide a key (a rough surface which provides a grip) for the adhesive. All the surfaces should then be sealed using PVA adhesive diluted with 50% water. This is particularly important around the edges of plywood, where the different layers of wood are exposed, and all surfaces of MDF.

For mosaics which will live outside or in damp areas, such as bathrooms, it is necessary to use marine or exterior grade plywood or moisture resistant MDF. Here the edges are at particular risk as water could seep in and cause the whole piece to warp. Edges can also be at risk from knocks and it is often better to enclose your mosaic panel in a frame. Hardwood battens can be glued and pinned along the edges or flexible brass or copper strips can be attached.

Furniture, frames or accessories with unfinished surfaces are easily available and should all be treated as described above, but varnished or painted surfaces or objects must be rubbed down first using coarse sandpaper. Cleaning with methylated spirits will ensure no grease remains. This is very simple to do as you just have to wipe the surface with a lint-free cloth soaked in methylated spirits. Within a few minutes the liquid will have evaporated leaving the surface clean and ready to treat with diluted PVA.

If decorating old pieces of furniture always make sure the piece is solid and in good condition – you do not want to discover it has woodworm and is about to fall to bits after you have decorated it!

Wooden floors can be decorated with mosaic but should first be boarded over with plywood at least ½" to ¾" (1.25 cm to 2 cm) thick. This should be treated with a diluted PVA mixture (50% PVA, 50% water) and screwed into the floor timbers at 6" to 9" (15 cm to 23 cm) intervals to ensure the surface is as rigid as possible. Joints will always tend to move slightly, if necessary they should either be placed where they will not show in the room or where the surface pattern will disguise any shifting. As before, if the surface is going to get wet marine exterior-grade ply should be used.

Terracotta and ceramic

Glazed china is more normally used as tesserae but plates and bowls can be used as interesting bases. As long as the surface is clean and dry the tesserae will probably stick on directly, but if you want to be sure, rub down the surface with coarse sandpaper and prime with a layer of diluted PVA. This is particularly important on vertical surfaces such as lamps or vases.

Terracotta is a very useful and versatile base as it comes in such a wide variety of shapes. It is porous and should therefore be primed with a dilute solution of PVA before being decorated. Garden pots with a lip or rim are particularly suitable as this will protect the edge of the mosaic from rain. An added advantage is that the mosaic will add an extra layer of insulation to the planter making the soil less likely to dry out.

■ The insides of these cups could be brightly decorated.

Sand & cement and stone

Using stone as a base tends to conjure up images of huge stone pillars or large expanses of terrace, but many objects made of reconstituted stone are quite reasonably priced and are very easy and satisfactory to decorate. Planters, fountains, bird baths and benches all work particularly well. These can be purchased from garden centres and DIY shops and as long as the stone has not been treated in any way, you can stick the tesserae straight onto it using either a cement tile

adhesive or sand and cement mortar. If in doubt, clean the surface with methylated spirits.

Cement floors provide a good base, but usually need to be professionally skimmed to ensure they are completely flat. This is particularly important in areas which will get wet as any irregularities in the surface will result in unsightly pools of water.

Walls need to be treated in the same way, but before you begin you need to ensure the wall is strong enough to support the mosaic. If in any doubt, ask the advice of a professional builder. The most suitable surface is a sand and cement render. This is waterproof and therefore can be applied to internal and external walls. The surface must be as smooth as possible to provide a good base for the tesserae which should be stuck on using a cement-based mortar. For more detail see the section on glues and grouts.

If the mosaic is outside, never subject it to frost while it is being made as the moisture in the adhesive and grout could freeze and expand which will weaken the cement and cause cracks.

Uneven stone surfaces such as garden walls, paths and even grottos can be mosaicked most effectively, but the stone should be rendered with sand and cement first to provide a good surface. Ensure the base is secure before you start – if it is not the extra weight of the tesserae and grout may cause it to collapse. Sand and cement mortar is usually the most suitable base layer.

Finally remember that mosaic decoration will considerably add to the weight of an object. This is particularly so with stone ornaments which are often decorated on all sides.

Plaster

This is another surface which can be used for interior walls which will not get wet – i.e. not bathrooms and showers. The plaster needs to be primed with a dilute solution of PVA and can then be used with cement-based adhesives. Painted plaster can form a base but the bond will only be as good as the bond between the paint and the plaster. In other words paint which is peeling and flaking off should be totally removed – you cannot rely on the tesserae's adhesive to hold it in place! Paint stripper will remove oil-based paint easily and the resulting surface can be re-skimmed or used directly depending on how flat it is. Emulsion paint should be rubbed smooth using sandpaper.

Glass

Mosaics using glass as a base can be very beautiful, especially if light is allowed to shine through them, for example, windows or candle holders. Tesserae are held in place using clear silicone adhesive. Black grout will give a stained glass effect.

Glass panels should be ¼" (0.6 cm) thick to provide the necessary strength. If you are having glass cut to a particular size or shape, remember to make sure the edges are polished otherwise they will be dangerous.

Net

Specialist net for making mosaics can be purchased either in sheets or on a roll. Tesserae can be stuck directly onto it and the whole sheet can then be put into place. This is especially useful for large mosaics, as it can be made in sections and then joined together and for mosaics in awkward spots, such as walls or ceilings, as the mosaic can be made in the studio and then fitted into place. The net remains behind the tesserae and the whole piece is usually stuck into cement or glued in place with epoxy resin glue.

Net is a very useful base as it can be cut into almost any shape and can also be bent gently to go round curves. Once it is fixed in place it can be grouted and any gaps between the tesserae will be filled.

Metals

Metal of most types can be used as a base for mosaics. One particular advantage it has is that thin sheets of metal are usually quite strong. If you are using old metal, you must check it for any rust spots and treat them first with preparations available from builders' merchants or car shops. Most metal surfaces will need to be roughened with wire wool and then primed with PVA. Tables, bowls, urns and trays can often be found at boot fairs and make ideal bases.

Tile backer board

This is a lightweight rigid mineral fibre board (up to 1" (2.5 cm) thick) which is used for construction in wet areas such as bathrooms. It can be cut easily with a stanley knife into interesting shapes and made into boxes, etc. The two sides are notched and firm, but you have to be careful as it has a foam-like centre which is exposed at the edges.

Paper

Papier mâché objects can be suitable for mosaics as long as they are strong enough to support the tesserae you have chosen. Trays, boxes and bowls can all make attractive bases.

Simple mosaics can be made using card or paper as a base. The tesserae are also paper, but of varying thickness, colour and texture. This type of mosaic is obviously not grouted, but providing a gap is left in between each paper tessera and none of them is allowed to overlap, the base colour will show through and become the grouted area.

Paper is also used as a temporary backing for mosaics made by the indirect method. This is fully explained on page 40.

■ Net is a very versatile base.

Adhesives

A great variety of adhesives is available and at first the choice may seem overwhelming, but in most instances the type you use will be determined by the base and tesserae and the final position of the mosaic. The glue must be compatible with all the elements involved and must be able to withstand the conditions of the site. The adhesives described below have been grouped in families or types. Each particular brand will vary slightly and you should always read the manufacturer's instructions carefully before embarking on a project. You should also be aware that while most adhesives are harmless, some are poisonous or give off toxic fumes. As a safe guideline always work in a well-ventilated room and if mixing dry powder wear gloves and a mask.

Types of adhesive

PVA (Polyvinyl Acetate)

This is one of the most useful and versatile types of adhesive. It is simple to use, gives off no toxic fumes and can easily be washed off your hands and tools using soap and warm water. It comes in tubs and

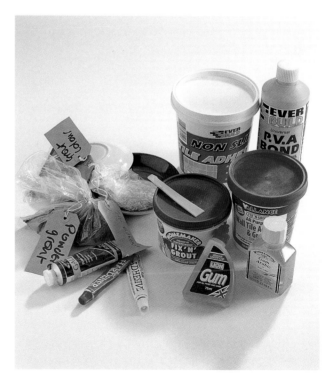

■ A selection of adhesives and grouts: PVA, epoxy resin, cement-based adhesive and sand & cement.

although it is white it dries clear so it does not matter if some oozes out between the tesserae when you use it.

Water-soluble PVA is not suitable for attaching tesserae to the base but it can be used for the indirect method of mosaic production. The tesserae are stuck, face down, onto brown paper (see page 40) and water-soluble PVA is suitable for this. It is stronger than wallpaper paste or gum arabic which can also be used.

Non water-soluble PVA is best for sticking reasonably flat surfaces such as tiles and ceramics to wooden bases. The base must remain horizontal as PVA does not dry immediately. It is also used as a sealer for wood, stone, terracotta and concrete. The adhesive is usually diluted 50–50 with water and then painted over the base to provide a surface which the glue will bond with.

Different types of PVA can be bought in hardware shops, for example, specialist wood glue. PVA can also be mixed with sand, cement, brick or marble dust to give interesting textured effects, but always check with the manufacturer's instructions to ensure you are not restricting the adhesion.

EVA (Ethylene Vinyl Acetate)

This is a waterproof version of non-water soluble PVA. It is useful for areas which will get damp such as splashbacks in kitchens or bathrooms, but cannot be immersed in water and should therefore not be used for objects which are permanently wet such as bird baths or fountains. It is also not recommended for use out of doors as the tesserae may work loose and fall off if the glue is subjected to frost.

Epoxy resin

This is a very strong adhesive which is made up of two separate parts. One tube or syringe contains the adhesive and the other contains the hardener. Equal quantities should be squeezed onto a piece of card or tile and then mixed together. The pack will contain a plastic spatula but metal spatulas or ice lolly sticks can also be used.

Epoxy resin is much stronger than PVA and can be used indoors or out and is suitable for mosaics which will get wet. However, it gives off fumes and should always be used in a well-ventilated room. It is thicker than PVA and can be applied in a thicker layer to accommodate uneven pieces such as curved china. Be careful not to let too much ooze out around the tesserae as the glue will show up when it dries.

Epoxy resin comes from hardware shops or builders' merchants and is available in two forms – slow and quick setting. The quick-setting version gives you about five minutes working time and then dries in about ten to fifteen minutes. The slow-setting version gives you about an hour to use it and then dries within about sixteen hours. Particularly with the quick-drying type it is more economical to mix up small batches of the glue as and when you need it.

Cement-based adhesive

This is a tiling adhesive which is based on a mixture of sand and cement, but is a more powerful adhesive and is easier to work with than simple sand and cement. It can be bought ready-mixed or in bags of fine white or grey powder which is then mixed with water. The powder is obviously slightly more work as you have to mix it yourself, but it is much more economical as the ready-mixed containers have a tendency to dry out. The other advantage of the powder is that you can add colour or other additives when you are mixing. For example, a latex additive such as Admix Ardion 90 will improve the flexibility and adhesion of the mixture if the base is liable to shift or if the mosaic is to be subjected to great temperature variations. Always check with your supplier as they will know which products are compatible.

Cement-based adhesives come in a variety of types – always read the instructions carefully as each brand varies slightly. The exterior type is frost-resistant and waterproof and there are slow- or rapid-setting mixtures to suit the type of work you are doing. Always make sure the base ingredient is Portland cement.

To mix, pour sufficient powder into a plastic bowl or onto a flat board and make a well in the centre. Add cold water and then mix well, to the consistency of soft mud, using a trowel or palette knife. The mixture should then be spread onto the base using a notched spatula so the tesserae will be able to grip the surface.

Wear gloves to protect your hands and wash your tools with warm soapy water in a bucket as soon as you have finished. This way any surplus mixture is easy to clean off. When the mixture settles at the bottom of the bucket you can drain the water out and clean the bucket with old newspapers or cloths which can then be disposed of in rubbish bags.

Cement

Cement is a fine grey powder which is made from a mixture of lime and clay. These are burnt (or calcined) to 1500°C and then finely ground. Portland cement is the most suitable one to use for mosaics – it is called this because the colour is the same as Portland stone. It has good adhesive strength and can also be used in areas which will be submerged in water.

Cement is mixed with sand to make a mortar. The ratios vary, but usually three to four measures of sand are used to one of cement. The sand should be sharp-washed sand which is available in various colours. It is also possible to vary the colour of the mortar by using cement pigments. These are added to the dry powder before the water is added and are available in shades of blue, yellow, green, red, black and brown. Always mix a small test sample and allow it to dry completely as the colour can vary as the cement dries. If you want brighter colours it is better to use white cement as a base.

The speed at which the cement dries will vary but lime can be added which will retard the drying time and also has the advantage of reducing the shrinkage and consequent risk of cracks. Cement Retarder or Mortar Plasticizer are also available to make the mortar easier to work with. As before ask the advice of your local builder's merchant or hardware shop. If you explain what your project is, they will probably be able to offer you the most suitable product.

The sand, cement and colouring pigment mixture should be put in a plastic container or on a flat board. Make a well in the centre and add the water slowly, mixing it in with a trowel. Always wear a mask when dealing with powdered cement and gloves as it can be an irritant to the skin. You will learn from experience what consistency you like to work with, but as a rough guildeline it should be the consistency of cake mixture. This mixture should then be spread on the base and the tesserae can be pressed directly into it. Remember not to push the pieces in too deeply if you are going to grout them afterwards.

Stone, brick or hard concrete are the usual bases. Cement mortar is ideal for floors. It should be spread in a layer 1" (2.5 cm) thick as this will absorb any differences of depth in the tesserae and allow for an absolutely flat surface. Unless you do not mind a certain amount of unevenness, floors are usually better made using the indirect method. The surface should first be wetted and then covered with a layer of slurry. This is mortar which has been watered down to the consistency of thick soup and will act as a bond between the base and the mortar. If you are working on a large project divide it into sections and complete each section one at a time.

Silicone adhesive

This is usually sold in cartridges for use with a specialist Mastic gun which is available from tile shops and builders' merchants. It is a clear jelly which can be used for sticking glass – either glass to glass or to another surface. It dries into a thick slightly rubbery state which allows for the expansion and contraction of glass. Any surface to which the glue is to be applied must be cleaned first using a lint-free cloth and methylated spirits. The spirits will quickly evaporate leaving the surface clean and dry. Squeeze the adhesive onto one surface and then place the other surface in place on top. Gently move the top piece

from side to side to ensure that the adhesive has firmly bonded to both sides. Try not to get the adhesive onto the surface of the glass as it is hard to remove. It is possible to buy products which will remove silicone adhesive, but you obviously have to use it carefully. Any adhesive which oozes out of the sides can be cut away once it has cured (dried) with a sharp knife or razor blade. Do not try to wipe it away while still soft, as you will be left with a fine layer of adhesive which will be much harder to remove. The jelly remains slightly cloudy when cured, but if a thin layer is used, this is not normally noticeable. If it is particularly important that it is totally transparent then clear, silicone adhesive is available from specialist glaziers.

Wallpaper paste

This is a water-based glue which is useful if you are making mosaics by the indirect method (see Chapter 7). It will hold the tesserae onto the paper firmly enough for you to create the design and transport it to its finished position, but it is easy to remove with warm water once the mosaic is firmly set in place. Any water-soluble glue can be used for this but wallpaper paste is cheap and you can mix up however much you need. Wear gloves when working with wallpaper paste as it can irritate the skin.

Gum arabic

This is a water-based gum which is also called Gum Mucilage. It can be used for the indirect method, but unless you are only making a small project it can work out expensive.

It is the most suitable adhesive to use if you are sticking paper or card tesserae onto similar materials.

Multi-purpose adhesives

There are a number of products which have recently become available which will stick a wide range of surfaces. They are solvent free which means they are safe and easy to use and will stick almost anything as long as one surface is porous. The only thing to be wary of is that most of these products are not waterproof and therefore cannot be used out of doors or in areas which will get wet – such as showers.

Cement-based products which will both stick and grout are also available. Their sticking power is not as great as the basic adhesive, but they can be useful for mixed media projects where it is important that the adhesive and grout both look identical.

Methods for direct mosaics

Buttering

The adhesive is placed directly onto the back of the tessera using a brush or knife depending on the thickness of the adhesive. The tessera is then laid directly in place on the base. The amount of glue can be varied to account for tesserae of different thicknesses but be careful that it does not squidge out around the tessera and onto the area which will later be grouted. This is a useful method if the design is drawn onto the base.

Applying the adhesive to the base

Another method is to cover a small area of the base with glue and then push the tesserae into it. This is the method to use if you also want the adhesive to act as a grout as it will push up in between the tesserae. It is useful for external projects where a surface layer is used to cover an uneven base, i.e. grottos or old uneven walls. It is also useful for embedding irregularly-shaped tesserae such as shells. The main disadvantage of this method is that when you apply the adhesive you obscure any drawings or marks you have made on the base.

PVA adhesive can be placed directly onto the base either in dots or long rows. The tesserae can then be pushed into place. This method is much quicker than buttering each piece individually but it is really only suited to uncut, uniform mosaic tiles as with irregular

pieces the dabs or rows of glue may be in the wrong place.

The method for using adhesives for the indirect method is described on page 40.

Hints and tips

Always try to make any corrections while the adhesive is still tacky. It is extremely hard to chip away pieces once they are set in place.

If you wish to mosaic up to a rim or corner always glue both sides at the same time so you can be sure that the tesserae meet up exactly.

If you are working on a vertical surface it is usually bettter to work upwards. Once the bottom row of tesserae are set in place they will stop the others sliding down.

For large, flat internal areas a grooved trowel can be useful for spreading cement-based adhesive. As you push the tesserae into the adhesive, less tends to squidge out around the tessera. For outside projects which might be subjected to frost, you must use a flat trowel to avoid any air spaces where water might collect and then freeze.

◼ Simple mosaics can be made using card or paper as a base.

6

Grouts

Not all mosaics are grouted and many people feel ungrouted mosaics show the tesserae off better and are more artistic. Some tesserae, such as smalti, cannot be grouted as the grout would become embedded in each tessera. However, there are still advantages to grouting your work – you end up with a nice smooth finish, the grout acts as an extra bond and strengthens the piece and by varying the colour of the grout you can alter the feel of the piece or even emphasize certain areas or tesserae.

There are two main types of grout; cement-based and epoxy. All the projects in this book which are grouted use cement-based grout which is probably all you will ever need. Epoxy grout is useful for certain special conditions and is described opposite.

Cement-based grout

Cement-based grout is available from builders' merchants or tile shops in either a ready-mixed form or as a powder. As with adhesive, it is often better and cheaper to buy it in the powder form and mix it yourself with water. Cement-based grout contains less cement than cement-based adhesive and is therefore not as sticky. Its purpose is to fill in the gaps between the tesserae but still allow slight movement to avoid cracking. Once dry it forms a reasonably waterproof surface, it can safely be used in pools, showers and fountains, but it will absorb some water so you should drain containers which are liable to be subjected to frost. (See epoxy grout.)

Cement-based grout comes in grey, black, cream, brown and white, but can be coloured by adding special colourants. Powdered colourant should be added to the grouting powder before you mix in the water and liquid colourant should be added to the water before mixing it in. As with everything, always read the manufacturer's instructions carefully. Colour can also be altered by mixing in acrylic or emulsion paint. It is safest always to mix up a small sample and let it dry completely as the colour frequently dries to a lighter shade. When mixing colours always be sure to mix enough or make an exact note of **all** the amounts to use as it is surprisingly difficult to reproduce a colour. If you want a deeply coloured grout, buy

coloured grout and then add more colour to it. White-based grout always tends to produce pastel colours.

It is possible to colour the grout once it has set in place using paint or stains such as tea or coffee but this can be very fiddly and is best avoided if possible.

Grout is mixed in the same way as cement-based adhesive. Pour the powder into a bowl or onto a board and make a well in the centre. Pour the water in slowly and mix with a trowel. It should be the consistency of soft mud. This will enable you to work the grout in between the tesserae, but will not cause it to shrink too much as it dries out.

Sanded grout has sand included in the mixture and is suitable for mosaics with large gaps between the tesserae. It should be used for anything with gaps over ¼" (0.6 cm) as ordinary grout will shrink too much and tend to crack.

It is possible to buy products which are combined grouts and adhesives. At first glance these seem ideal but they are not suitable for all projects. They are not always as strong as a single adhesive and can be harder to clean off the tesserae afterwards than grout. They are just what is needed, however, for many smallish projects. A final word of warning – as with all cement-based products – never pour the excess down the sink as it can easily block the drains.

Epoxy grout

This is useful where the grout needs to be completely impervious to water. As said in the previous section, cement-based grout will produce a waterproof surface but will always absorb a small amount of liquid. As epoxy grout is non-porous, it is stain resistant. This makes it suitable for areas such as cooking surfaces, dressing-table tops and any other areas which could be subjected to staining liquids. Epoxy grout is resin-based and comes in two parts which are mixed together in a similar way to epoxy adhesive. Be very careful using this product and always read the instructions carefully. It cures (sets) very quickly so until you are accustomed to using it, only mix up small quantities. Coloured variations are available.

As you will see, if you go into a specialist shop, there is a great range of grouts available – indoor, outdoor, quick-drying, etc. If in any doubt which to use, always ask in the shop as they will be able to advise you.

Techniques

There are two main methods for making mosaics: Direct and Indirect. Both of these are described in this chapter as well as several variations for creating mosaics in different situations.

Direct method

The instructions here are for vitreous glass tesserae on a wooden base. The techniques for all direct mosaics are the same, but for different bases and tesserae you should consult Chapters 2 and 4.

With this method tesserae are placed directly onto the base. It is the easiest and most adaptable way to create a mosaic and the technique is the same for bases ranging from wood and cement to china and for almost any tesserae from traditional Venetian smalti to broken china bought in a junk shop.

Before you start any mosaic it is vital to ensure you have sufficient tesserae to complete the project. There is nothing worse than having to rethink a design half-way through because you have run out of a particular colour. With this in mind, draw your planned design onto the base. If you do not feel confident enough to draw a design yourself, simply transfer a design you like using carbon or tracing paper, remembering that if you use tracing paper your design will be reversed when you place it face down on the base.

■ Mosaic design drawn on a wooden base.

■ Left : Mosaics using a variety of shaped tesserae.

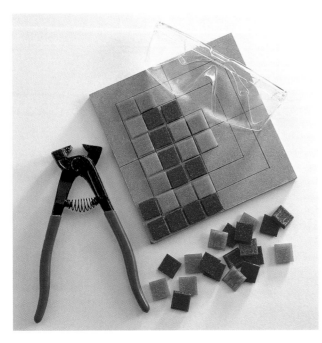

■ Tesserae placed on the design.

For wood or smooth cement, a pencil can be used to mark the design. If the base surface is shiny, as with glazed china for example, use a permanent felt-tip marker. It will not matter that the lines cannot be removed as they will be covered by tesserae and grout. For works which are not grouted, ensure your lines are just inside the design's edge. Having drawn your pattern out, roughly, fill in the areas with the tesserae you have chosen. If you are cutting pieces, follow the instructions given in the earlier chapter on tesserae and always be sure to wear protective goggles.

Even if you intend to place the tesserae randomly on the base, it is always worth laying a section of them out first. When you finally glue them in place their positions will alter, but you will still gain a useful rough impression by laying the pieces out first. A pile of tiles and broken china can look totally different when laid out on a flat board and you may find you need more or less than you thought of a particular colour. At this stage you do not need to cut the

tesserae exactly, but you should check that you have sufficient of each type for your chosen design.

Having made sure that you have enough pieces, clear them off the base making a note of any placings you wish to repeat exactly. It may seem a waste of effort to place all the pieces out twice, but it really is worth it since the whole design could be spoilt if you run out of pieces or change your mind during the 'gluing on' stage.

The base now needs to be primed so that the tesserae can be stuck on to it. It is always best to prime a base even if you think the pieces will adhere to it and this stage is very quick and easy. Detailed instructions are given in Chapter 4. Wooden surfaces can be scratched with a hacksaw blade to give the glue something to grip onto and all surfaces should then be covered with a layer of diluted PVA (50% water to 50% PVA is usually suitable) or other acrylic-based bonding agents using an ordinary household paintbrush. Wooden bases need to be sealed on all sides, whereas unglazed ceramics need only be treated where the tesserae will be placed. Acrylic-based glues should stick directly onto glazed china providing the base is clean and slightly roughened using coarse sandpaper. Do not worry that the PVA is white, it turns clear when it dries and any design you have drawn on the base will show through. Leave this for at least an hour until the surface coating has dried.

The tesserae can now be glued in place. It is usually easiest to work outwards from the centre, completing each section individually, although you may be governed by the overall design. Lay the tesserae out again, but this time place them exactly where you want them, cutting any pieces as necessary as you go along. Try to avoid holding the pieces directly over the base when you cut them as little chips of unwanted glass or china will fall on the design and get in the way. If you have enough room it is best to have the base at one end of a table with the tesserae spread around it and the cutting area further along.

If you are not using grout, the tesserae should be placed as close together as possible. If you are using grout, the distances in between the tesserae will not matter so much but should ideally be reasonably uniform. They should not be so small that it will be

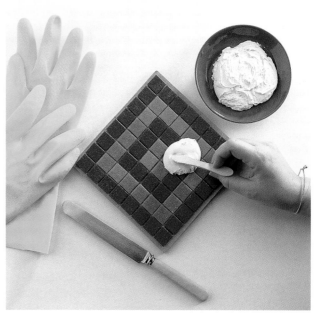

■ Grout being spread onto the mosaic.

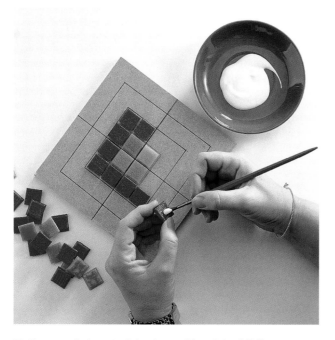

■ Tesserae being stuck in place with a dab of PVA.

hard to work the grout in between the pieces, but gaps of more than $^3/_{16}$" (0.5 cm) tend to look unsightly. These gaps can usually be avoided by inserting a smaller piece of china or tile in between the larger ones. It can be worth making a test sample with different widths of grout – it can alter the appearance of a design quite dramatically. See the diagram on page 103.

Once you are happy with the positioning of the tesserae, glue them in place. Pick up each piece individually and put a dab of PVA glue on the reverse. Details for gluing particular types of tesserae are given in Chapter 5.

There should be enough glue to ensure the piece is firmly stuck in place, but try to avoid using too much

as it will squidge up around the sides. It is also possible to spread a layer of glue over a small area of the base and then place the tesserae onto this, but you need to be able to work quickly and accurately before the glue dries. Whichever method you use, be very careful that all the pieces are placed correctly – this is particularly important with straight lines as any mistakes will be magnified as you work along the row. After gluing the pieces in place, leave to dry for at least twenty-four hours before grouting.

As explained in Chapter 6, you can use ready-prepared grout or mix your own, adding colour pigment as desired. Wearing rubber gloves to protect your hands (grout is surprisingly rough and without them you will soon find the top layer of your skin is worn away!), place a generous dollop of grout onto the mosaic.

Using a plastic spatula or squeegee, spread the grout across the mosaic ensuring it is well worked down in between the tesserae. For small gaps you can push the grout down with your fingers. Allow the grout to set

for about twenty minutes and then wipe off any excess with a damp lint-free cloth or sponge. Be careful that the cloth is not too wet as you will wash away all the grout. At this stage it is also possible to fill in any gaps you may have missed earlier. If your tesserae are uneven, for example, a mixture of broken china, tiles and beads – you will need to be particularly careful at this stage not to wipe too much grout away in between the pieces.

Finally, when the grout is reasonably dry, wipe the mosaic with a clean dry cloth and remove any remaining pieces of unwanted grout with a non-scratch nylon scourer or a smooth piece of wood such as the end of a ruler or lollypop stick, being very careful not to scratch the tesserae. Removing excess grout at this stage can be very fiddly and time-consuming, but it is much easier to do while the grout is still slightly soft and it is therefore worth spending some time completing this stage really carefully.

Leave aside until the grout is completely dry. This usually takes twenty-four hours, but will vary according to the thickness of grout you have used. The finished piece can then be polished with a solution of liquid floor cleaner. This will restore the shine to the tiles, china and mirror pieces.

Self grouting

The technique here is exactly the same as the method just described but the gluing and grouting stages are combined. It is used for smalti as it is extremely hard to grout a smalti mosaic satisfactorily. This is because smalti have tiny air holes which the grout will work its way into and then be almost impossible to remove. It is also a useful method to use where the tesserae are unevenly shaped and do not have a flat bottom to stick onto the base. Shells, beads and curved crockery are usually best attached using this method.

Prepare the base as before and check you have sufficient tesserae. These are then stuck in place using cement-based tile adhesive. If you wish this can be coloured by adding acrylic paint or cement dye (see

sections on adhesives and grouts). If you are making a mosaic with a variety of types of tesserae it is possible that you will only use this method for some areas (see ship firescreen on page 52). If this is the case, be sure that your grout and adhesive are the same colours. You can either stick the tesserae in place by spreading a layer of adhesive on the base and pushing them into it or by buttering each tesserae with adhesive. In practice a combination of both methods is often the most satisfactory.

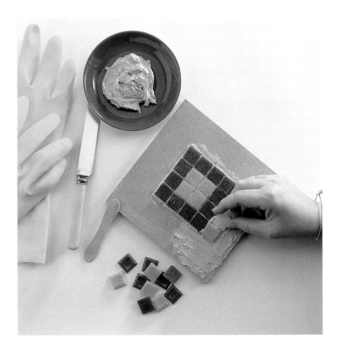

■ Tesserae being embedded in cement-based adhesive.

The first method, which follows now, is usually the best one for sticking smalti in place. Spread the adhesive over the base using a flexible blunt-ended knife or spatula. Cover a small area at a time as cement-based adhesive is usually quite quick to dry. Most take about twenty minutes to set so do not cover an area larger than you can complete in that time. The adhesive should be level and deep enough so that it comes half-way up the sides of the tesserae when they are embedded in it.

Once all the tesserae are stuck in place, leave to dry. This will probably take about twenty-four hours. The mosaic should not need cleaning, but any stray bits of adhesive can be gently removed using a damp lint-free cloth or craft knife.

Direct method on a 3D object

The preparation for this method is the same as for the basic method. See Chapter 4 for an explanation of how to prepare various types of base. Depending on how three-dimensional your base is, you may or may not be able to lay the tesserae out on it to check your design. If you cannot, it is worth drawing the different faces of the base, or parts of them onto paper and laying the tesserae out on them to ensure the design is all right and that you have enough tesserae to complete it. Depending on the type of tesserae you are using they can be stuck in place using any adhesive (PVA or cement-based adhesives are usually the most suitable).

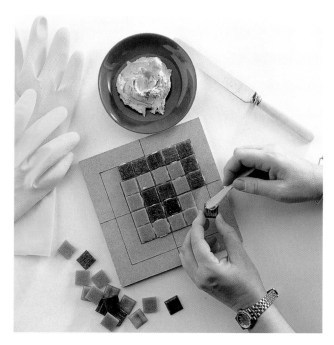

■ Tesserae being buttered with cement-based adhesive.

You can check the thickness of the layer of adhesive by inserting the end of the knife into it. Push each tesserae firmly into place, but do not push it right down to the base – they will stick better if there is a layer of adhesive between them and the base as well as around the sides. This sounds difficult but it is actually very easy as you can feel the adhesive squidging out around the tesserae and once you have stuck a few pieces in place you will know how far to push them down.

The second method is to butter each tessera individually with the cement-based adhesive. It is usually best to spread a thin layer of adhesive on the base and then push the butttered tesserae into this.

If the tesserae have an uneven base, like a shell base, ensure that all the gaps are filled with adhesive.

When using these methods be careful not to get any adhesive on the surface of the tesserae as it is difficult to clean off.

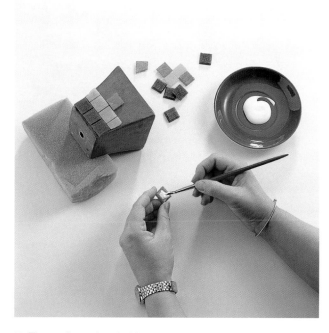

■ Three-dimensional objects can often be wedged so the face you want to decorate is lying flat.

It may be possible to lay the object at an angle so that you can work on a flat surface. Old sponges are particularly useful for wedging awkward shapes. If this is possible decorate one face, leave to dry for twenty-four hours and then move the piece round to decorate the next face. Be careful to ensure any joins at corners are neat.

When turning the object round, be careful not to damage faces you have already decorated. Once all the tesserae are firmly glued in place you can grout it using the same technique. As before, be particularly careful at the corners.

decorate each section at a time and move the object round once the previous section is dry.

If you have to work on a vertical face, stick a small section at a time and wait until that has set. If possible, work upwards from the base. This way each row of tesserae will be able to rest on the previous firmly set row.

You may need to hold some of the tesserae in place while you wait for the adhesive to set. If this is the case use a fast-acting adhesive. (PVA, epoxy resin and cement-based adhesive all come in quick-drying types.)

■ The second row of tesserae can rest on the first row which is already set in place.

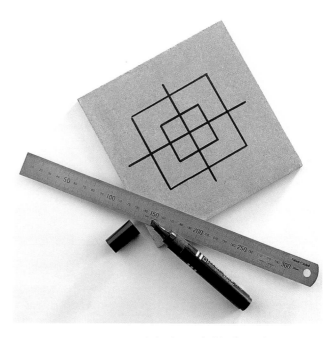

■ The outline of the mosaic is drawn in black marker pen.

It may be that it is not possible to position the object so it has a flat face to work on. Circular lamp bases, vases and larger objects such as fountains usually fall into this category. Small vases and lamps can usually be wedged using cloths or sponges so that there is a reasonably flat face to work on. If this is possible

Mesh base

Mesh or net is particularly useful if you wish to make a mosaic in the studio and then transport the finished object to its final position. The advantage over the indirect method is that the work is completed face-up so you can see exctly what you are doing. As you are working right-side up you can also use tesserae of different thicknesses if you want certain areas to stand out.

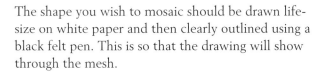

■ The drawing clearly shows through the protective layer of polythene and the mesh.

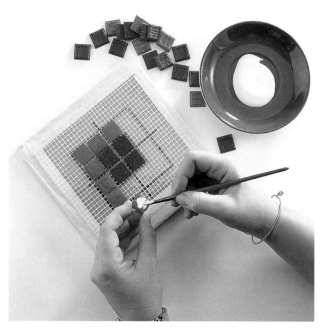

■ For interior mosaics PVA can be used to fix the tesserae in place.

The shape you wish to mosaic should be drawn life-size on white paper and then clearly outlined using a black felt pen. This is so that the drawing will show through the mesh.

The finished drawing should be fixed onto a flat surface and covered with a clear polythene sheet or clingfilm so that the mosaic will not stick to the paper. The mesh should be cut to a square or rectangle slightly larger than the drawing and placed on top so the drawing shows through. Fixing everything to a wooden board with drawing pins or masking tape holds all the layers firmly in place.

The tesserae can then be stuck in place. It does not matter if the whole things sticks to the polythene as it will easily peel away afterwards. If the mosaic is going to be indoors the tesserae can be stuck in place using PVA adhesive or tile adhesive but if it is to be outside you should use a cement-based adhesive which is suitable for exteriors.

Once all the tesserae are stuck in place, leave the mosaic for at least twenty-four hours until the pieces are firmly stuck. Gently cut the mesh away as close as possible to the edge of the design using a stanley knife.

Mix up more cement adhesive and spread a layer onto the final position for the mosaic. The thickness will depend on the tesserae you are using but as a rough guide the cement adhesive layer should be deep enough to come half-way up the tesserae when they are embedded in it ($\frac{1}{8}$" (0.3 cm) for thin tesserae, $\frac{1}{4}$" (0.6 cm) for thicker or uneven tesserae such as pebbles or beads).

Gently lift the mesh mosaic – you may need another person to help if the mosaic is large – and position on the adhesive. Gently push down into the adhesive using a flat piece of wood to ensure even pressure.

Leave for at least twenty-four hours until the cement adhesive has cured and is firm and then grout following the instructions on page 35.

Indirect method

The indirect method of making mosaics involves sticking the tesserae face down on a sheet of paper and then setting them into a cement base. Once the tesserae are firmly set the paper is removed and the surface of the mosaic revealed. It was greatly used in the nineteenth century by Lorenzo Radi, a Murano glassmaker, and Antonio Salvati, a lawyer and man of ideas, although it may have been used by the Romans to construct the emblemata for their floors and walls several thousand years earlier.

On a domestic scale most mosaics can be made by the direct method which is usually easier as you can see what you are doing as you go along. The indirect method is useful, however, if you are constructing a large-scale mosaic as it can be designed and made in the workshop and then transported to the site in its finished form. It also provides an absolutely flat surface, which is useful for floors, even if the tesserae themselves are of different thicknesses. This method can also be used on gently curving surfaces such as pillars or bowls of fountains.

The main problem about creating a mosaic using this method is that everything has to do be done in reverse. This is particularly difficult for any mosaic involving lettering or a design where direction is important. Also, because the pieces are placed face downwards on the paper it is difficult to see what you are doing unless you use tesserae which are similar front and back. Vitreous glass tiles or ceramic mosaic tesserae are most suited to this method. Ordinary tiles can be used but you would need to label or mark the back of each tesserae so as to be able to identify it.

Unless you are constructing a very simple geometric pattern it is easiest to draw the design life-size on a sheet of white paper. Lay the tesserae out roughly to check you have enough of each colour. Using tracing paper, transfer the design onto brown craft paper. This will reverse the design, but it will be reversed back to its original direction when it is embedded in its base.

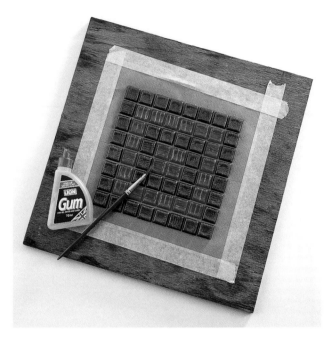

■ Only a small amount of glue is needed to stick the tesserae to the brown paper.

The best paper to use is thick brown craft paper. It usually has a smooth side and a rough ribbed side. It does not matter which way up you use it, but the tesserae sometimes stick better to the ribbed side as the ribs act as a key for the adhesive.

Spread the brown paper out and if necessary weigh it down at the edges so it lies flat. Remember to protect the lower surface with newspaper in case any of the glue seeps through. Cut the tesserae and stick face down on the brown paper using water soluble glue such as gum arabic or wallpaper paste.

Do not use too much glue otherwise the paper will shrink. If in doubt leave slightly larger gaps in between the tesserae to compensate for any shrinkage. It is possible to pre-shrink the paper by wetting it first and then drying it flat but this should not be necessary if you do not use too much glue. Remember the glue only has to hold the tesserae onto the paper temporarily.

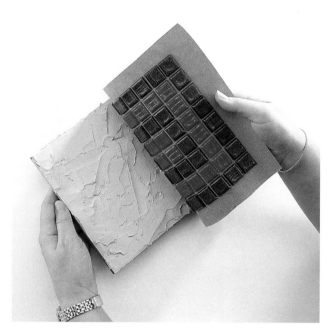

■ Place the brown paper over the base so the tesserae are embedded in the adhesive.

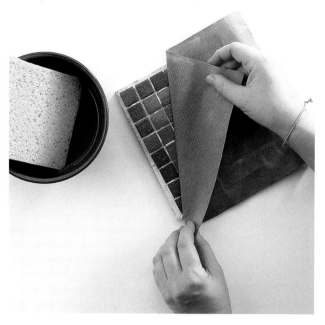

■ Pull the paper back gently, parallel to the surface of the mosaic.

Once you have stuck the tesserae in place on the brown paper, weigh it down with a wooden board to ensure that the brown paper does not wrinkle up as it dries. Allow the glue to dry thoroughly.

Spread a layer of cement-based adhesive over the area where the mosaic is to be set. It should be deep enough to embed the tesserae in, but not so deep that they sink into it. If you are using tesserae of different depths remember to make the layer of adhesive deep enough to accommodate the largest tesserae. Lift the brown paper and gently lay the mosaic on top of the adhesive. Unless the mosaic is very small this is usually easier with two people. Press the tesserae gently into place by rubbing over the brown paper with a soft cloth. A gentle circular movement will ensure the tesserae do not slip.

Leave the mosaic for two to three hours until the adhesive has set. The backing paper can now be gently removed. Dampen the paper using a sponge or cloth

and then leave for a few moments to allow the water to sink through and dissolve the glue. Peel the paper back very slowly. If any tesserae come away with the paper, it means that the adhesive on the base has not set and you should wait longer before removing the paper. Pull the paper back along the face of the mosaic, not at right angles to it, as this will make it less likely that the tiles will become dislodged.

If a few tiles become unstuck they can easily be recemented into position at this stage.

The mosaic should then be left for twenty-four hours and grouted and cleaned in the same way as for the direct method on page 35.

It is possible to pre-grout the mosaic while it is on the paper. Once the tesserae are firmly stuck to the paper, grout the piece using a squeegee. Then wet a tiler's sponge and wring it out so it is almost dry. Using this, gently clean off all the excess grout. The pre-grouted

mosaic is extremely fragile and should be stuck in place within twenty minutes so the grout does not dry too much and crack. Once set in place the mosaic should be left to harden and the paper removed as described above. You will find that some grout has oozed onto the surface of the tiles and that other areas need more grout to fill in the gaps. Pre-grouting adds an extra, quite delicate stage to the whole procedure and is only really necessary if it is vitally important that none of the adhesive shows through. In most cases it is easier to colour the adhesive to the same shade as the grout so it will not matter if a little does show through to the surface of the mosaic. If the finished object will not be subjected to rough wear and tear a single adhesive and grout mixture can be used.

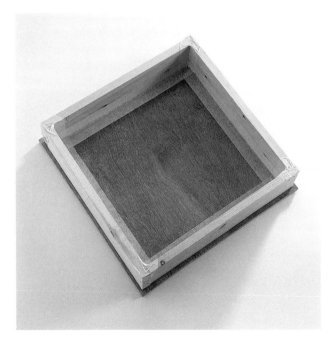

■ A simple wooden casting frame.

Sandbox

This method is suitable if you wish to create a paving stone or cement panel with irregular tesserae such as pebbles.

Before you start you need to make a wooden frame within which the slab will be made. The pieces of wood should be 2½" × ½" to ¾" (6 cm × 1.25 cm to 2 cm) and ¾" (2 cm) longer than the finished slab. (This will allow the battons to be fixed together to form the frame.) You will also need a base 1" (2.5 cm) larger than the finished size of the slab. The base and internal sides of the frame should be varnished so they will not warp.

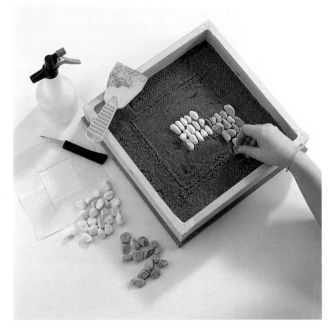

■ Push the pebbles into the sand following the design you have drawn out.

Fix the frame together at the corners, place on the base and seal all the joins with waterproof tape. Fill the base with ½" to ¾" (1.25 cm to 2 cm) of sand and flatten. The depth of the sand will be the height the tesserae stand out above the concrete. Remember, as you push the pebbles in, the level of the sand will rise around them so the depth will become slightly greater.

Draw your design onto the sand using a sharp pencil, or the point of a thin craft knife. Push the pebbles in following the lines of the design and then fill in the gaps.

Push the pebbles in firmly until they touch the base of the frame. (The base of the frame will become the surface of the finished slab so it is important the pebbles are all level.) Try not to move the pebbles as they will not be so well supported by the sand. This is

movement which might dislodge them. Once all the gaps between the pebbles are filled, add more cement to a depth of 1" (2.5 cm). Lay a square of chicken wire onto the slab and continue adding cement up to the edge of the frame.

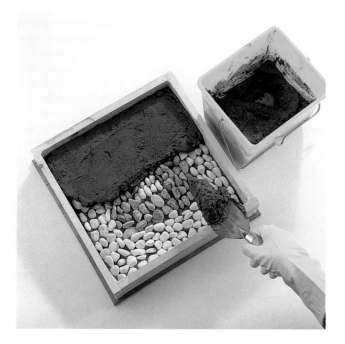

■ Make sure the cement mixture fills all the gaps between the pebbles.

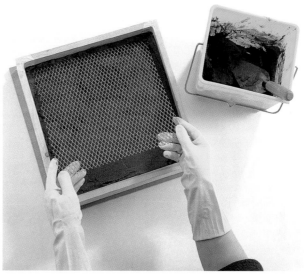

■ A layer of chicken wire will strengthen the finished slab.

easier if the sand is kept moist as it will grip onto the sides of the pebbles. The sand should not be soaked, just spray it with a water spray. Pack the pebbles in as tightly as possible – on the finished slab any gaps will show as plain concrete.

Once all the pebbles are in place mix the concrete (one part cement to three parts sand) adding sufficient water so that the mixture is soft enough to push down between all the pebbles. It is most important that all the gaps between the pebbles are filled.

Be very careful not to dislodge any of the pebbles. At this stage it is better to push the mixture down onto the pebbles rather than spreading it with a sweeping

Smooth the surface of the concrete and cover with a layer of polythene. This will prevent the concrete drying too fast and cracking. Leave the slab to set for about one week.

Unscrew the frame and remove the wooden sides. Gently turn the slab over and remove the wooden base. Brush away the sand and clean the slab with a jet of water from the hose.

The finished slab is extremely strong and will last for years, indoors or in the garden.

8

Projects

Whether you are an experienced mosaicist or an absolute beginner, you will be able to make all the projects listed here with ease and pleasure. The majority of them require very little specialist equipment – in most cases all you need, apart from your basic materials, are nippers and a pair of goggles. In some cases you will not even need these. Although a studio or workshop is, of course, the ideal place to make mosaics, your kitchen table will do just as well. These projects include direct and indirect methods. Tesserae include glass tiles, smalti, ceramic tiles, beads, buttons, shells, pebbles, crockery and metal pieces.

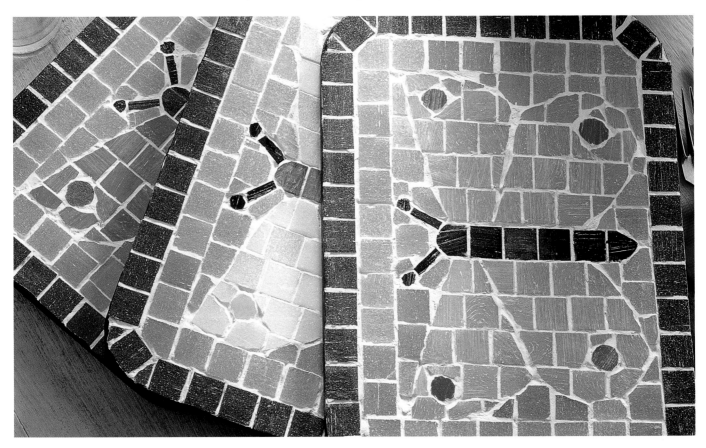

Project 1 · Shell letter rack and pen holder

Equipment needed

- MDF letter rack and pen holder (see suppliers)
- Assortment of smallish shells
- PVA adhesive
- Cement-based adhesive (coloured beige)
- Paintbrush
- Pencil
- Palette knife
- Beige household paint

Working the design

Lay the shells out to make sure you have enough. You can place them randomly but the different shells appear more distinctive if they are grouped together. If they are all randomly laid out they have a tendency to look rather dull. If you want to work out a patttern, draw around the letter rack or pen holder onto a piece of plain white paper and test your designs on that. Remember you need to decorate all four sides of the pen holder, but you need not decorate the back of the letter rack unless you wish to. Having decided on your design you need to seal the surfaces by painting on a diluted solution of PVA (50% water, 50% PVA). Leave this to dry for about an hour.

Working on one side at a time, lay the piece so the face lies uppermost and flat and spread a layer of cement-based adhesive over the MDF surface. Be very careful at the edges, as it will not be easy to tidy them once the shells are in place. The layer should be about ¼" (0.6 cm) deep. Carefully position each shell and push it into place. It should sink into the adhesive far enough to be held firmly in place, but not so far that the shape of the shell is obscured. If the shell has any hollows at the back, for example, cockle shells – fill these gaps with adhesive first as this will make the shell stick better. Allow the side to dry thoroughly (probably about twenty-four hours) and then repeat the procedure for the other sides.

When all the sides are set, paint the exposed surfaces with household paint in a colour to match the grout.

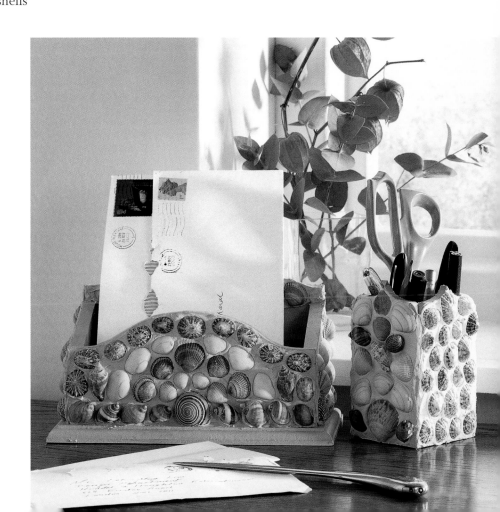

Project 2 · Classical design desk top

Equipment needed

- MDF desk top (surface area 15" × 9" (38 cm × 23 cm) – see suppliers)
- 99 blue vitreous glass tesserae
- 71 green vitreous glass tesserae
- PVA adhesive
- Grout (coloured blue)
- Paintbrush
- Ruler
- Pencil
- Palette knife
- Lint-free cloth or sponge
- Green household paint

Working the design

This is a particularly easy project as no cutting is involved. Because of this it is possible to gauge exactly how many tesserae you will need. Using the pencil and ruler find the central point of the desk top and divide the area into quarters by drawing a horizontal and vertical line through the central point. This will ensure that the lines of tesserae remain level. Seal all the surfaces with a dilute solution of PVA (50% water, 50% PVA) and leave to dry for about an hour.

Glue the tesserae in place working outwards from the central lines following the diagram on this page. When all the tesserae are stuck in place and you are sure they are level, leave to dry for about twenty-four hours. Grout the piece following the instructions on pages 35–36. The grout can be coloured blue using acrylic paint or coloured grouting powder. At the edge of the mosaic area fill in the gap between the tesserae and the MDF base, but try not to get too much grout on the MDF base. You will probably find it is easiest to smooth it into place with your finger. Leave for twenty-four hours to allow the grout to set and then clean following the instructions on page 36. After this you can paint the remaining surfaces using household paint. When painting the inside of the box remember to wedge it open using a lolly stick or similar object as otherwise the lid will stick shut.

■ Template for the classical design desk top.

Project 3 · Smalti jewellery box

Equipment needed

- Wooden box
- Sandpaper
- PVA adhesive
- Smalti: dark blue, pale blue, yellow
- Cement-based adhesive (coloured blue)
- Spatula
- Paintbrush
- Dark blue paint
- Goggles
- Nippers or hammer and hardie

Working the design

Boxes in attractive shapes can be found in craft shops or bought from suppliers specializing in blanks. If you buy the box from a craft shop, make sure it is sturdy enough to support the smalti – wood is fine, but not all papier-mâché is strong enough.

If the box is decorated, rub it down with sandpaper before sealing it with a dilute solution of PVA (50% water, 50% PVA). MDF boxes should be sealed on all surfaces

Lay the smalti out to check that you have enough and that your design fits on the box. Following the instructions on page 36, stick the smalti in place. If you are decorating the sides of the box, do each one in turn, allowing it to dry completely before moving on to the next side. Decorate the lid last.

When the adhesive has set, paint any exposed area of wood dark blue. Allow the paint to dry and then fill the box will all your jewels!

Project 4 · Jewel lamp

Equipment needed

- Lamp with circular china base
- Rough sandpaper
- Glass nuggets and flat-backed beads
- Quick-drying cement-based tile adhesive (coloured green)
- Spatula

Working the design

This lamp is designed to create the effect of sparkling jewels shining out from a cool, minty-green background.

If the base is glazed, i.e. shiny, rub it over with coarse sandpaper to provide a key for the adhesive. You need not remove all the glaze, but make sure the whole surface is rough.

Lay the beads and glass nuggets out to make sure you have enough and check to see if any of them have smooth bases which will also need to be rubbed with sandpaper. Spread a fairly thick layer of cement-based adhesive around the bottom of the lamp. It should be deep enough to accommodate the first row of glass nuggets and thick enough for the nuggets to be firmly embedded. Start far enough up the base so the tesserae will not get knocked when the lamp is moved, ¼" to ½" (0.6 cm to 1.25 cm) is usually sufficient. Once you have pushed the glass beads in, allow the adhesive to set. Depending on the type you are using, it will probably take about an hour. It need not be completely solid but it must be firm enough to stop any of the glass beads from slipping down the side of the lamp. Once the first layer is firm, you can complete the second row following the same procedure. The adhesive will squidge up between the rows, but this does not matter as it enhances the icy feel of the background of the piece. Try to avoid getting adhesive on the surface of the tesserae as it is hard to clean off.

Wait for the next layer to dry and then continue up to the top of the lamp base. Once the first layer is firmly set, it will act as a support for the next layer and so on.

Your lamp is now ready to use. If you wish you can add to the effect by using a coloured light bulb.

Project 5 · Geometric table top

Equipment needed

- 3-ply wooden base 14" (35 cm) square × ⅜" (0.9 cm) deep
- Household tiles: blue, red and green
- PVA adhesive
- Grout (coloured sandy or pale yellow)
- Paintbrush
- Spatula
- Nippers
- Goggles
- Pair of compasses (optional)
- Ruler
- Pencil
- Dark green paint
- Sandpaper
- Lint-free cloth or sponge

■ The geometric table top.

Working the design

This was made to fit on the broken top of a small table base. Decide on the size of your base first since it may influence what size top you want. Also bear in mind what height the finished table will be.

Break the tiles up roughly and separate the edge pieces which will be used for the edges of the table. Draw your design on to the wooden base using a pencil or felt-tip pen. Check you have enough tiles to fill in the pattern. The wood now needs to be sealed with a dilute solution of PVA (50% water and 50% PVA). Remember to do the edges as well. Leave to dry for about an hour. Wearing goggles, use the nippers to cut the tiles to the correct size. It is easiest if you work outwards from the centre and complete one section at a time. Put a dab of PVA on the back of each tessera and then push firmly into place. Once you have glued all the pieces in place, leave to dry. This will probably take twenty-four hours.

Grout and polish following instructions on pages 35–36. Allow the grout to dry for twenty-four hours and then paint the edges dark green. The table top is now ready to be fixed to the base. To a certain extent how you do this will depend on the base, but in most cases epoxy resin will be strong enough to join the top and base.

Project 6 · Ship firescreen

Equipment needed

- ⅜" (0.9 cm) ply board 23½" × 16½" (59 cm × 41 cm) rising to 19" (48 cm) as shown in the diagram (check this is suitable for your fireplace)
- Two wooden legs 1" × 2" × 8" (2.5 cm × 5 cm × 20 cm) with triangular ends
- Template (see below)
- Tiles (if you use tiles of an equal thickness, the plaque will be flat. Unequal tiles will give an interesting finish but will be more difficult to grout). Pale blue: sky, Black: ship, Navy: waves, Orange: flag, Green: flag, Yellow: sun
- Shells: sails and base (varnished if you wish)
- Pebbles: border
- Glass nuggets: water
- Brass keyhole covers: flags and portholes
- PVA adhesive
- Grout (pale blue)
- Cement-based adhesive coloured in the same blue
- Acrylic paint for the edges
- Goggles
- Tile nippers
- Pencil or marker
- Sandpaper
- Paintbrush
- Palette knife
- Sponge
- Polishing cloth

Working the design

This ship is not technically accurate, but it is inspired by the type found in many children's books. It is bobbing along on a sea of glass nuggets which are irridescent and reflect the light beautifully.

■ Template for the ship firescreen.

Get your timber merchant to cut the wood for you following the dimensions below. Smooth any rough edges with sandpaper and then draw the ship onto the board using the template opposite.

19"
(48 cm)

16½"
(41 cm)

←——— 23½" (59 cm) ———→

■ Dimensions for the base of the ship firescreen.

Make sure at this stage that the ship, sun, waves and any other features are exactly as you want them. Once the mosaic tesserae are glued down they will be extremely hard to alter.

Once you are happy with the design you need to prime the surface of the wood, including the sides by painting on a layer of diluted PVA (50% water, 50% PVA). Once this has dried it will become clear and your drawing will show through. (This will take at least an hour.) You can now lay all the tesserae in place. By doing this you can be sure you have enough of each colour and that the arrangement looks good.

You are now ready to glue the tesserae in place. Begin with the waves and put a blob of PVA on the back of each tile and press it firmly in place. Next complete the ship, masts and ceramic flags, leaving room for the portholes and sails which will be added later. Glue the pieces for the sun and sky in place and then leave to dry. This will take at least twenty-four hours

■ The ship firescreen

depending on the amount of glue you used. Grout in between all the tiles following the instructions on page 35. Make sure the areas for the brass flags, portholes, sails, sea and edging remain clear. Allow the grout to dry and clean the tiles following the instructions on page 35. It is much easier if this is completed before you add the irregularly shaped tesserae (shells, pebbles, glass nuggets and brass fittings).

When you are happy that the grouted areas are clean, mix up the cement-based tile adhesive to a similar shade of pale blue. If in doubt, mix up a small portion and allow it to dry to check that the colour matches the grout. Taking one section at a time, spread a layer of adhesive onto the base so it comes just below the level of the tiles. Push the tesserae firmly into place so they are embedded into the adhesive which will then act as a grout around them. Allow the whole thing to dry for at least another twenty-four hours and then paint the exposed wooden edge with acrylic paint, again in a similar colour to the grout and adhesive. Your firescreen is now completed and simply needs its legs to be added. Paint each one pale blue to match the edge of the board. When the paint is dry, screw each one into the base of the firescreen. Remember that the longer the legs are, the more stable the firescreen will be.

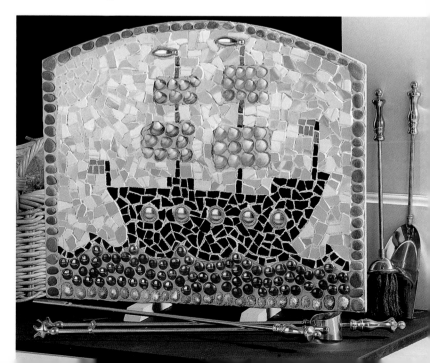

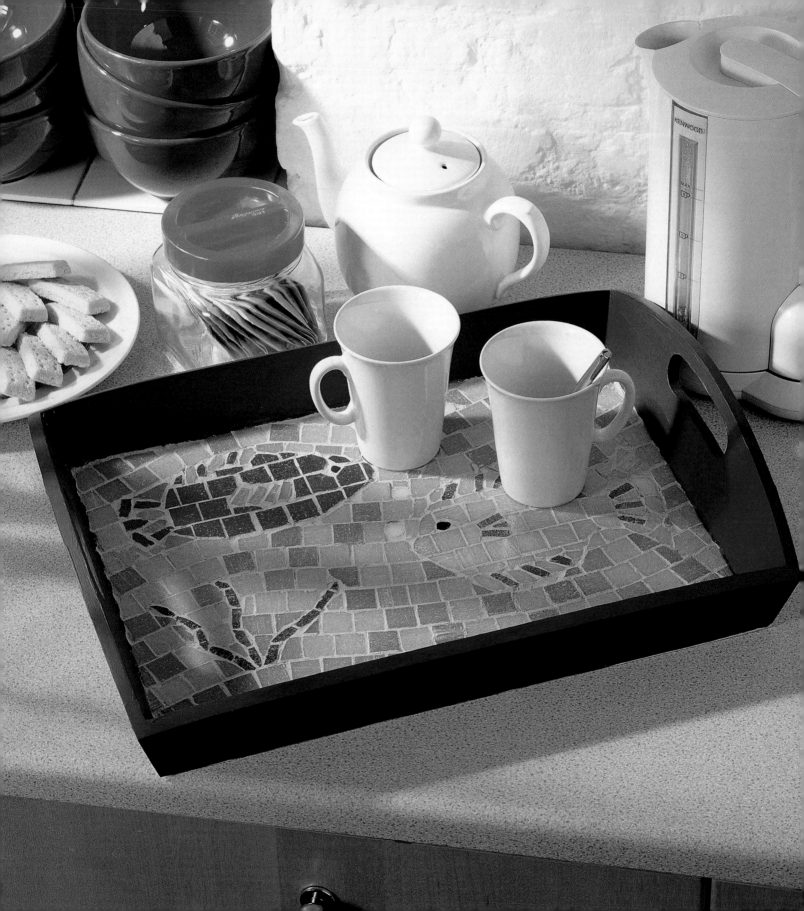

Project 7 · Tray with fishes

Equipment needed

- Ready-made MDF Tray 12" × 16" (30 cm × 40 cm) (see suppliers)
- PVA adhesive
- Cement-based grout (coloured blue)
- Vitreous glass tesserae: mixed aqua blue, sand, green, yellow, dark blue, purple, pink, white
- Pencil
- Tracing paper
- Paintbrush
- Palette knife
- Nippers
- Goggles
- Lint-free cloth or sponge
- Blue household paint

Working the design

Using a photocopier, enlarge the drawing opposite so that it fills the base of your tray. Remember if you transfer the tracing directly the design will be reversed. Lay the vitreous glass tesserae out roughly on the design to ensure you have sufficient of each colour. At this stage you do not need to cut the pieces exactly. Remove the tesserae and seal all the surfaces of the tray using a dilute solution of PVA (50% water, 50% PVA). Allow this to dry for about an hour and then glue the tesserae in place by putting a dab of PVA on the reverse of each piece. Wear goggles and use nippers to cut each tessera to the correct shape. It is easiest if you complete the fish, bubbles and seaweed first and then fill in the background. When doing this be sure that you keep the angles of the curves the same all the way up the tray. Allow the glue to dry for about twenty-four hours and then grout the tray following the instructions on page 35. The grout can be coloured using acrylic paint or coloured grouting powder. Be careful not to get grout up the sides of the tray as it will be difficult to clean off. Once the grout is set and the tiles have been cleaned, paint the remaining surfaces with blue household paint.

■ Templates for the fish

■ The tray with fishes.

Project 8 · Floral wastepaper basket

Equipment needed

- Ready-made MDF wastepaper basket 11½" (29 cm) high
- Household tiles: turquoise, navy, pale green, dark green, orange, yellow
- Cement-based grout (coloured yellow)
- PVA adhesive
- Paintbrush
- Pencil
- Tracing paper
- Nippers
- Goggles
- Lint-free cloth or sponge
- Navy blue household paint

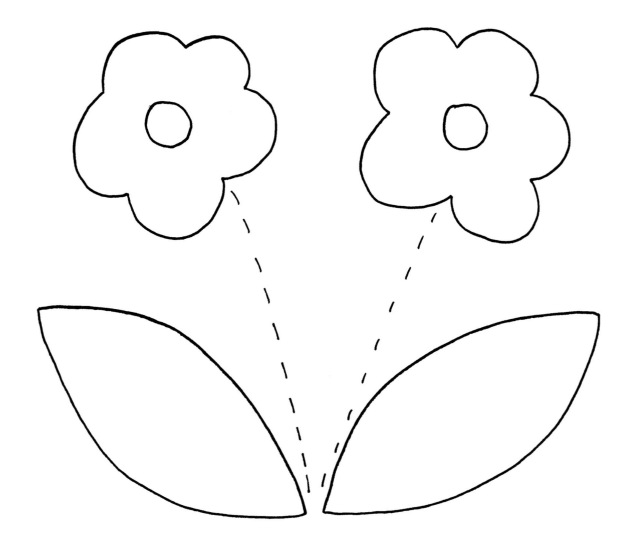

■ Template for the flowers – the length of the stems will depend on the height of the wastepaper basket.

Working the design

Enlarge the drawing opposite using a photocopier and transfer onto the wastepaper basket. Remember that if you transfer the tracing directly you will reverse the image. Seal all the surfaces with a dilute solution of MDF (50% water, 50% PVA). Wearing goggles, cut the tiles so they fit into the design. Use the sides of the tiles to go round the edges. Once you are satisfied, lift each piece in turn, put a dab of PVA on the reverse and push it firmly into place. Once all the tiles are secure, leave to dry for twenty-four hours. Mix the grout, colouring it with acrylic paint or coloured grouting powder. Grout the piece following the instructions on page 35. When the mosaic area is clean, paint the other surfaces of the wastepaper basket navy blue to match the background tiles.

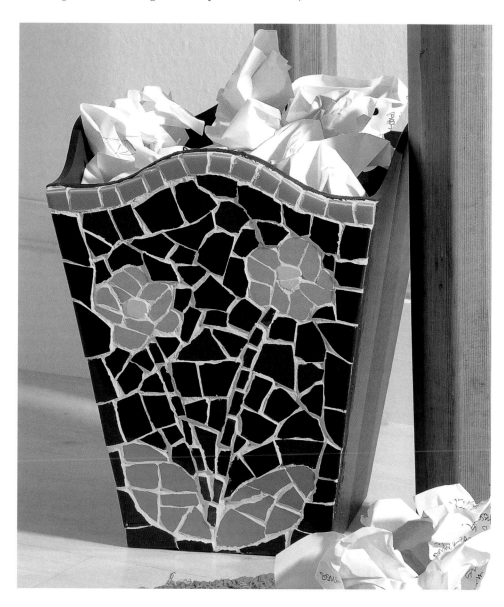

■ The floral wastepaper basket.

Project 9 · Seaside mirror

Equipment needed

- ⅜" (0.9 cm) board 19½" × 13½" (48 cm × 34 cm) cut as shown in the drawing
- Plate rims to go around the edge of the frame
- Vitreous glass tiles in blues, greens and pinks to edge the mirrors
- Glass beads, shells, broken crockery
- Two mirrors cut as per the diagram
- Two wooden blocks 2" × 1" × ⅜" (5 cm × 2.5 cm × 0.9 cm) for hanging support
- Two small screws
- Cord
- PVA adhesive
- Epoxy resin adhesive
- Ready-mixed grout and tile adhesive (pale blue)
- Goggles
- Tile nippers
- Pencil or marker
- Ruler or tape
- Sandpaper
- Paintbrush
- Palette knife
- Lint-free cloth or sponge

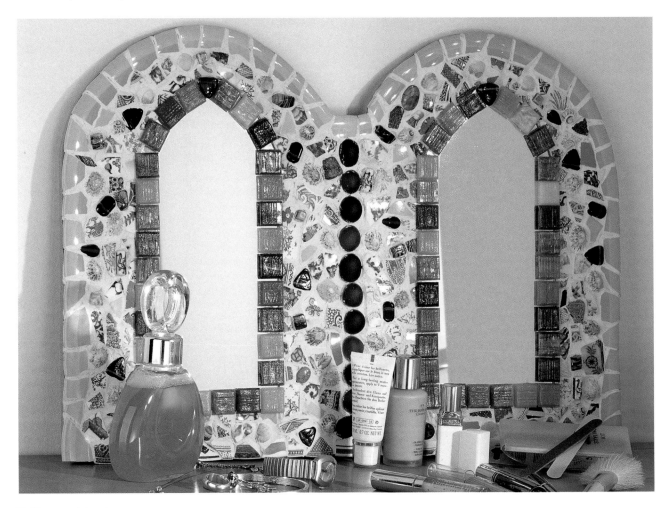

■ The seaside mirror.

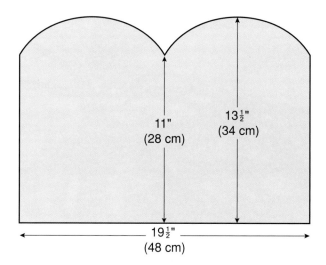

11"
(28 cm)

13½"
(34 cm)

19½"
(48 cm)

9½"
(24 cm)

4½"
(11 cm)

■ Dimensions for the base and mirrors for the seaside mirror.

Working the design

China softened by the sea and washed up on a beach was the inspiration for this mirror. Try to choose china with pale, faded patterns and blues, greens and purples for the glass and beads.

Get your timber merchant to cut the wood for you following the template (left). Smooth any rough edges with sandpaper and then prime the wood by painting the front and sides with a dilute solution of PVA (50% water, 50% PVA). Allow this to dry thoroughly – this will probably take about an hour. Glue the mirrors in place in the centre of each arch. You can use silicone adhesive or epoxy resin to do this. Put all the tesserae in place using the plate rims around the edge. Position the tesserae right up to the edges of the mirrors, but make sure that they are no higher than the level of the mirror. Glue all the ceramic tesserae in place by buttering the back of each one using PVA glue. At this stage leave the shells and beads in place as they will be fixed with the grout/adhesive later. Allow the glue to dry which will probably take about twenty-four hours.

Grout the mosaic using pale blue grout/adhesive mixture, following the instructions on page 35. This will allow you to push the beads and shells into it as you go along. Be careful not to get any on the tops of the shells as it will be hard to clean off. Clean the surfaces and allow to dry for at least another twenty-four hours. Lay the vitreous tiles upside down over the edges of the mirrors so they cover the join of the mirror and tesserae. A triangular bead at each apex will give it a neat finish. Glue the tesserae in place using PVA and allow to dry.

To hang the mirror, screw a hook into the top of each small piece of wood. Glue these to the back of the frame using epoxy resin. When this has dried, attach the cord and hang up your mirror.

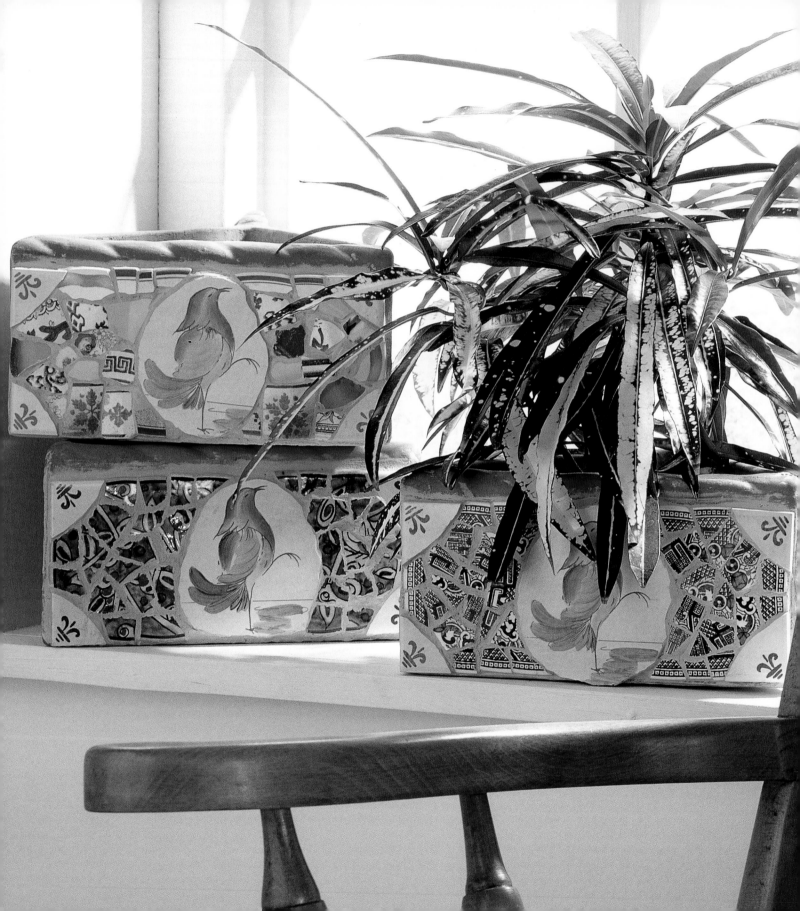

Project 10 · Triangular planters

Equipment needed

- Three interlocking terracotta planters
- Three china motifs, one for the centre of each planter
- Twelve corner pieces, four for each planter
- Broken tiles or crockery
- PVA adhesive
- Epoxy resin
- Paintbrush
- Nippers
- Goggles
- Terracotta coloured grout
- Lint-free cloth or sponge

■ The triangular planters.

Working the design

These three planters interlock and rest attractively against a sunny wall. The advantage of having your flowers or herbs in separate planters is that it prevents the invasive ones, such as mint, taking over the whole area.

Wedge the planter so the decorated face lies horizontally – triangular planters like this can be wedged in a bucket. Seal the area to be decorated with a dilute solution of PVA (50% PVA, 50% water). Allow about an hour for this to dry. Lay the tiles out, if possible using edge and corner pieces around the sides. Wearing goggles, trim any tiles with nippers to fit around the central motif. Using epoxy resin stick the pieces in place, starting with the central motif, then the edges and finally the infilling. Epoxy resin is more suitable than PVA for outside and also it can be built up in a thicker layer if the pieces of crockery are not absolutely flat. When all the tesserae are in place, leave the planter to dry for twenty-four hours. Grout the mosaic following the instructions on page 35. Smooth the grout with your finger around the edges of the mosaic so that there is a smooth join between mosaic and terracotta.

Leave for twenty-four hours and then plant up with your favourite herbs or flowers.

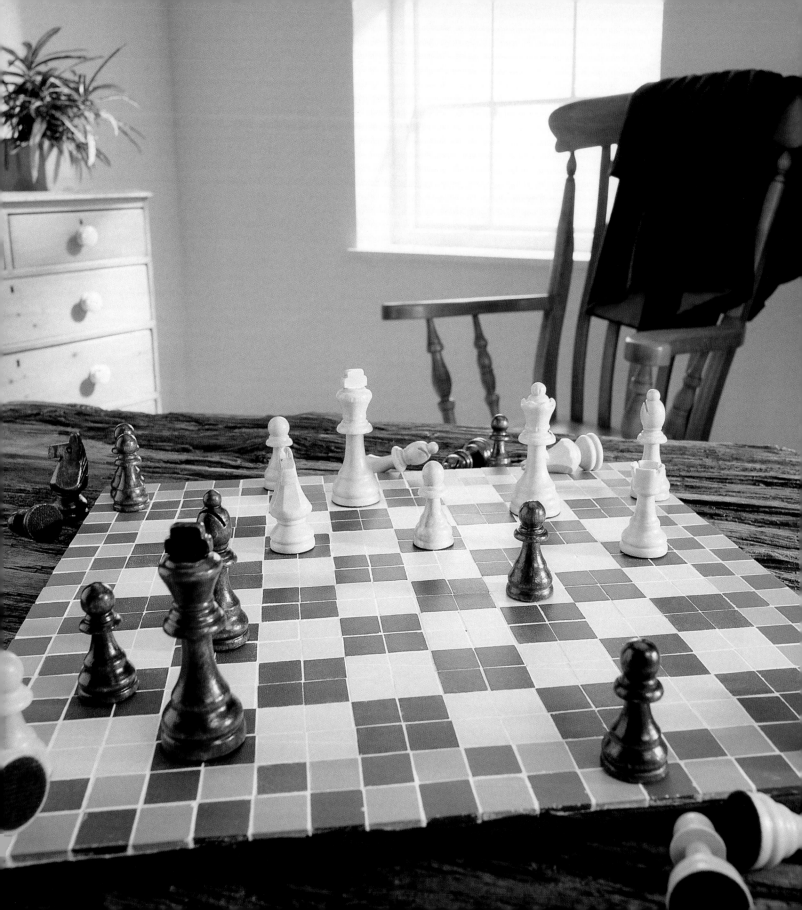

Project 11 · Chessboard

Equipment needed

- ¾" (2 cm) matt ceramic tesserae:
 black × 128
 white × 128
 pale blue × 72
 dark blue × 72
- Brown craft paper
- Gum arabic or wallpaper paste
- Paintbrush
- Cement-based grout and adhesive mixture
 (exterior quality if the chessboard will live outside)
- Spatula
- Lint-free cloth or sponge
- 3-ply wood base – 16" × 16" × ⅜" (40 cm × 40 cm × 0.9 cm) (unless you are embedding the chessboard onto an existing surface)
- Household paint if using a wooden base

Working the design

This chessboard is made using the indirect method as it is important that the finished surface is completely flat. If you are making it on a board you can stick the pieces straight on with PVA adhesive, but using the indirect method allows you to embed the chessboard into an uneven surface such as an old garden table or even a garden wall so you can play with your neighbours.

With the diagram as a guide, stick the tesserae onto the brown paper following the instructions on page 40. Complete the chessboard following those instructions. If you are embedding the chessboard onto an uneven surface, remember to put enough adhesive mixture down to cover all the irregularities as the surface of the chessboard must be flat.

If using a wooden base, paint any exposed areas of wood with household paint. Allow the grout to dry and polish with a lint-free cloth before settling down to your first game.

■ Pattern layout for the chessboard.

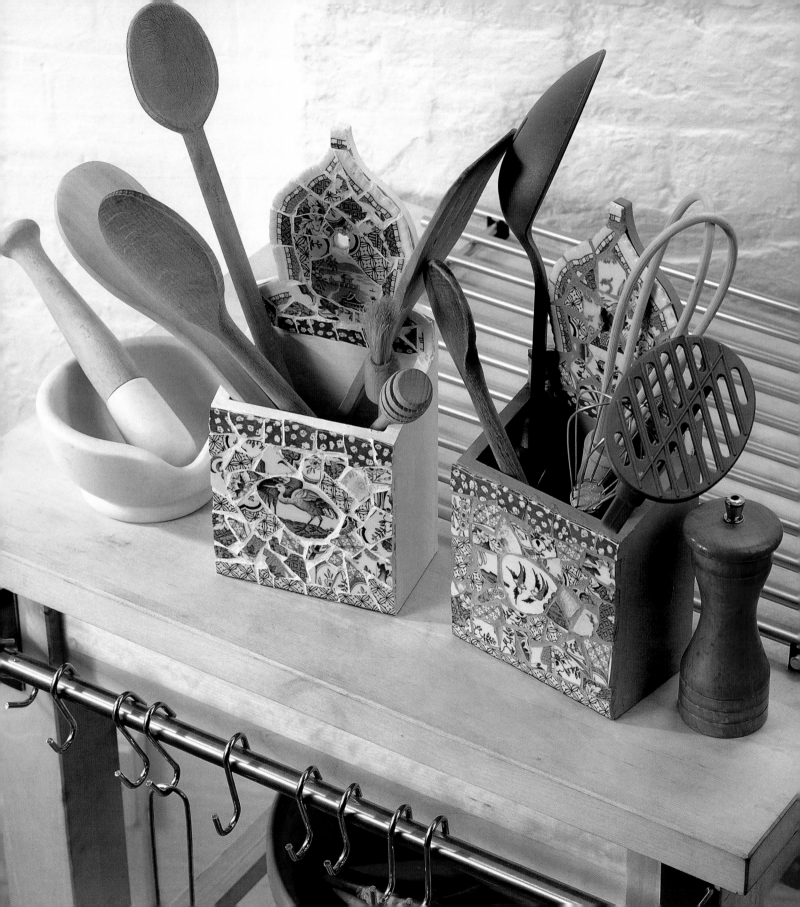

Project 12 · Oriental holders

Equipment needed

- Ready-made MDF wall holder (see suppliers)
- PVA adhesive
- White grout (or pale blue)
- Blue and white crockery
- Paintbrush
- Goggles
- Nippers
- Palette knife
- Lint-free cloth or sponge
- White or blue household paint

Working the design

These attractive wall holders have been made from broken pieces of blue and white china. Blue and white is an attractive combination of colours and will match almost any colour scheme. An added advantage is that blue and white is the most popular colour for crockery and therefore pieces can easily and cheaply be found in charity shops and jumble sales.

Lay the china out and see if there are any striking motifs which could be used as central pieces for the front and back faces of the holder. Wearing goggles, nip them to the required size and lay in place. Next lay the tesserae around the edge using edge pieces of china if possible. You need not cut them exactly to size but make sure you have enough to fit right around the back and along the top and bottom of the front.

Remove the pieces and seal the holder with a dilute solution of PVA (50% water, 50% PVA). Make sure you seal **all** the surfaces thoroughly as the MDF base could warp if it gets wet.

Allow the sealer to dry. This will probably take about an hour. Stick each of the pieces in place putting a dab of PVA glue on each one. Stick the central motifs in place first and then the edge pieces. Finally cut the remaining china to fit the gaps in between, remembering to wear goggles whenever you are cutting tesserae.

Lie the holder flat so the tesserae do not slip and leave to dry for twenty-four hours.

Grout in between the tesserae following the instructions on page 35. If you wish to make the blue version, colour the grout with blue acrylic paint or coloured grouting powder. Allow to dry lying flat for at least twenty-four hours. Clean and polish the tesserae and then cover the remaining exposed surfaces in household paint to match the grout.

Project 13 · Peacock

Equipment needed

- Mosaic Mesh 35" × 15" (88 cm × 38 cm)
- PVA adhesive and grout for use indoors or waterproof cement-based adhesive and grout for outdoors
- Vitreous glass tesserae:
 Body: blue, white, black, orange
 Legs: black with gold veins
 Wing: green, beige, orange-yellow
 Tail: red, brown, yellow, turquoise green, gold
- White paper 35" × 15" (88 cm × 38 cm)
- Clingfilm or other clear polythene 35" × 15" (88 cm × 38 cm)

- Thick black marker pen
- Masking tape
- Wooden board at least 37" × 17" (93 cm × 43 cm)
- Nippers
- Goggles
- Paintbrush
- Spatula
- Lint-free cloth or sponge

Working the design

This peacock is based on one of a pair in St Mark's Cathedral in Venice, Italy. In the Christian church peacocks are used as a symbol of resurrection or immortality. The peacock here was enlarged to 32" × 12" (80 cm × 30 cm). You can enlarge the diagram to any size you like either by using a photocopier or by using a square chart as explained in the chapter on design (page 105).

When the peacock is the size you want, transfer the outline onto the sheet of plain white paper. The black

Template for the peacock.

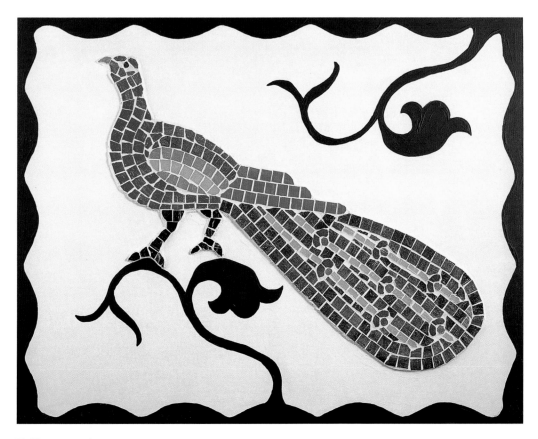

■ The peacock.

outline will probably show through the paper so you can copy it. If it does not show through, you can use tracing paper. Remember to check which way round you want the peacock to face. You can change the direction by using tracing paper.

Draw over the outline using a thick black marker pen. This will allow the design to show through the mesh. Fix the paper in place on the board using masking tape and then cover with a layer of polythene following the instructions on page 38. Make sure you have enough tesserae. If you are unsure lay them out on the paper outline first, at this stage it is still easy to alter the pattern to accommodate any shortages.

The type of adhesive you use will depend on the final position of the finished peacock. If it is going to be

outside or in an area which gets wet you will need to use a waterproof cement-based adhesive and grout. If it is not going to get wet, PVA adhesive and ordinary grout will be sufficient.

When sticking the tesserae in place, it is easiest to complete the outline of the bird first and then work inwards. This ensures the outline is relatively smooth. Cut the pieces to the correct shape using goggles and nippers.

One final word of warning – be very careful when transferring the grouted peacock into its final position. It is extremely fragile at this point and you will almost certainly need two people to move it.

The peacock in this project has been fixed to an MDF base and the background has been painted on.

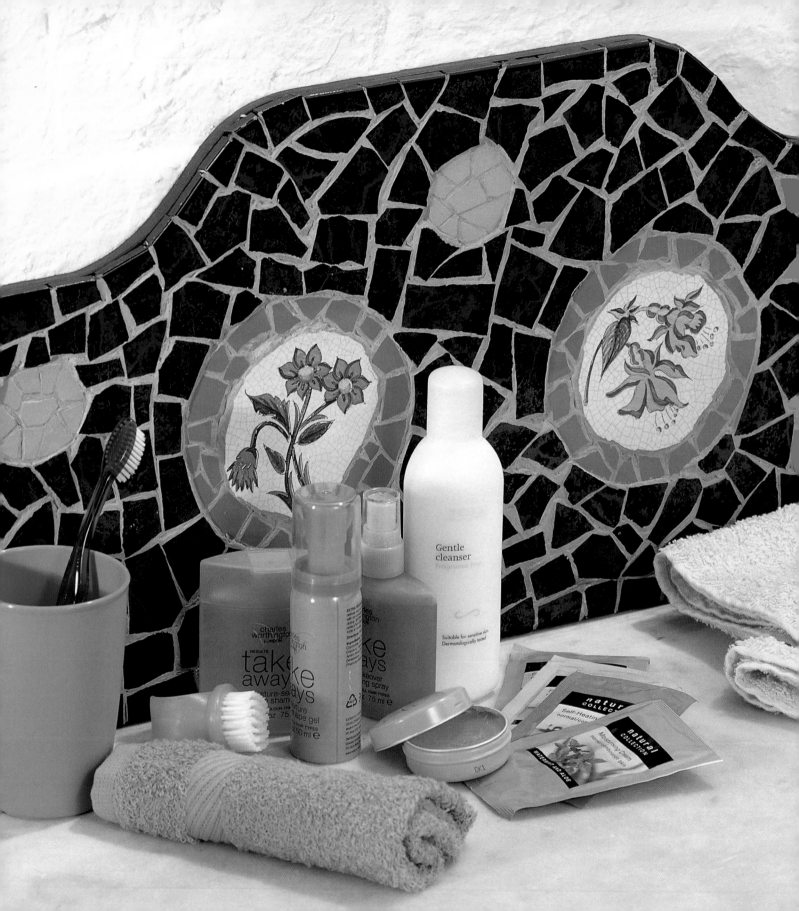

Project 14 · Splashback with flowers

Equipment needed

- ⅜" (0.9 cm) ply board 24" × 11½" (60 cm × 29 cm) cut as shown in the diagram
- Two tiles with central motifs
- Household tiles: green, orange, blue
- Grout (pale blue)
- Dark blue acrylic paint for edges
- PVA adhesive
- Goggles
- Nippers
- Pencil
- Ruler or tape measure
- Pair of compasses (optional)
- Sandpaper
- Paintbrush
- Palette knife
- Sponge
- Polishing cloth

Working the design

This splashback provides a bright focus point for any bathroom. Choose tiles and patterns to match the colour scheme already in place. Before cutting the wood, check it is the correct size for the sink you are going to put it above. The design of the mosaic is very simple and can easily be adapted to make the piece slightly larger or smaller. Get your timber merchant to cut the wood to the correct size following the diagram (left). Smooth any rough edges with sandpaper. Trim the two central motifs to the required size and position on the board. Draw a circle around each motif and three more smaller circles. You can draw the circles using a pair of compasses, a jam jar lid or freehand depending on how exact you want to be.

Prime the surface and sides of the wood with a dilute solution of PVA (50% water, 50% PVA). Once this has dried (it usually takes one hour) glue the tesserae in place. It is easiest to start with the motifs and circles, putting a dab of PVA on the back of each tile and pressing it firmly into place. When cutting the blue background save the edges and corners of the tiles as they will probably be slightly curved and will look better around the edge of your mosaic. Stick these edge pieces first and then fill in the rest of the spaces. If you use larger tesserae than the ones used for the circles it will help them to stand out. Leave the mosaic for at least twenty-four hours to dry and then grout and polish following the instructions on page 35.

Allow the grout to dry for twenty-four hours and then paint the edges dark blue to match the tiles.

The splashback now needs to be attached to the sink. Depending on the wall, you can either use sand and cement or a multipurpose adhesive. If in any doubt ask your local supplier or get a professional decorator to fix it for you.

■ Dimensions for the base of the splashback.

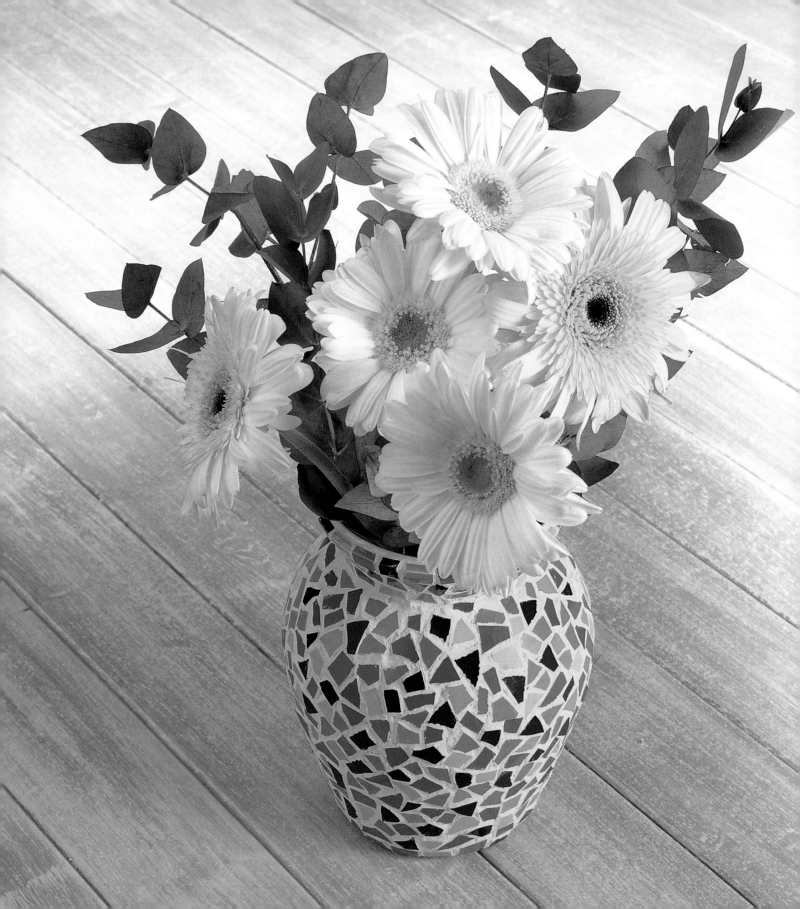

Project 15 · Yellow vase

Equipment needed

- Plain china vase (yellow)
- Selection of plain household tiles
- Sandpaper
- Cement-based grout (coloured yellow)
- PVA or cement-based tile adhesive
- Nippers
- Goggles
- Palette knife
- Lint-free cloth or sponge

Working the design

The vase shown here is decorated with a selection of plain household tiles. By altering the colour of the base vase or the tiles you can adapt it to suit your chosen setting. In fact you can be as flexible as you like in your selection of tesserae – for example you could match the vase to your kitchen tiles or even your dinner service. Remember you will need to match up the colour of the grout as well.

Rub the surface of the vase with coarse sandpaper to remove the glaze and provide a rough surface for the adhesive to hold on to. Wearing goggles, break the tiles up into small pieces using the nippers. Put the edge pieces to one side for the top and bottom of the vase and divide the tiles into four roughly equal piles. Following the instructions on page 37, stick the tesserae in place one quarter at a time. You can either use PVA or cement-based tile adhesive. Stick the tiles around the top and bottom rims first and then move in towards the centre. If you find the pieces are slipping, work more slowly and wedge the vase so that each small section can lie horizontally while it dries. (Old sponges are useful for wedging delicate objects in place.) Once all the pieces are in place, allow the adhesive to set for at least twenty-four hours before grouting. Colour the grout to match the inside of the vase and finish off following the instructions on page 35.

Project 16 · Bookends

Equipment needed

- Wooden bookends with an interesting shape/design (these dragons came from a charity shop so always keep your eyes open for interesting bases)
- Selection of beads, mirrored pieces and glass nuggets
- PVA adhesive
- Sandpaper
- Cement-based adhesive (coloured purple)
- Palette knife
- Paintbrush
- Purple household paint

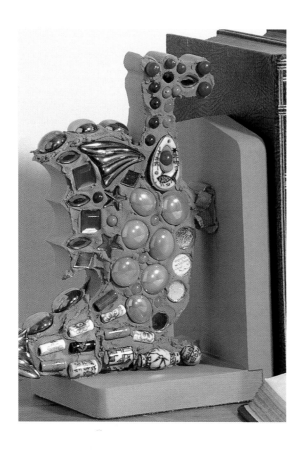

Working the design

The instructions which follow apply to the dragons, but would be applicable to any similar object.

Brush the dragons to remove any loose dirt and rub with sandpaper to remove any varnish. Seal the surfaces with a dilute solution of PVA (50% water, 50% PVA) and allow to dry for about an hour.

Divide the tesserae into two piles so that the two bookends will be roughly similar. The division need not be exact but you want to try to avoid the situation where one end is covered with glass nuggets and the other end has none. You can either lay the pieces out on the dragon itself or draw around the outline on a sheet of paper and lay the tesserae out on that. In many ways the latter option is easier as you can then stick the pieces onto the dragon one at a time without losing the overall layout. When you are happy with the layout, mix up the adhesive, adding purple acrylic colouring. (Coloured grouting powder is not available in purple.) Spread a layer onto the dragon covering a small area at a time and embed the tesserae into it. The depth of the adhesive should allow the beads to sink into it halfway up their sides. If the adhesive does not come up this far, the pieces will be in danger of falling off and any further up will spoil the look of the finished object. Push the pieces in as neatly as possible as the exposed adhesive will act as the finished grout surface. Cement-based adhesive is more difficult to clean off tesserae than grout, so try not to get any on the surface of the beads. Leave the dragon lying on its side to allow the adhesive to dry – this will probably take twenty-four hours but will depend on the thickness of the adhesive.

Once the side is dry you can repeat the procedure and decorate the spine of the dragon. Again, allow this to dry thoroughly. Paint any exposed areas with household paint in a colour which matches the adhesive.

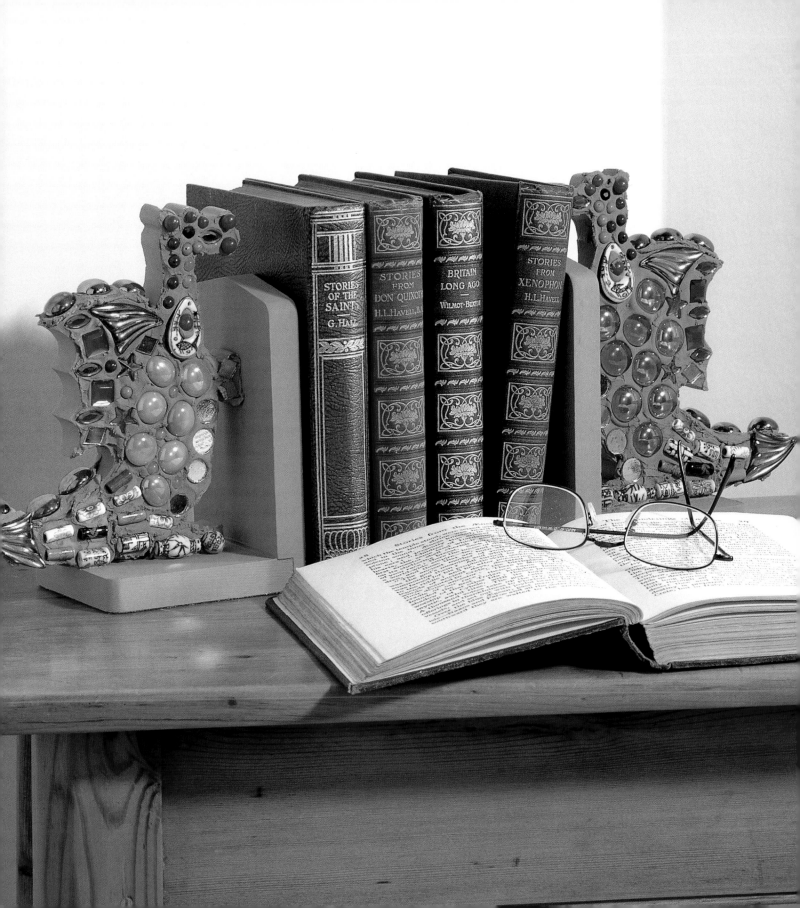

Project 17 · Butterfly placemats

Equipment needed

- Three MDF place mats 12" × 8½" (30 cm × 21 cm)
- Vitreous glass tiles:
 Mat 1: green, pale blue, orange, pale green, black, brown/gold
 Mat 2: green, pale blue, yellow, red, black, brown/gold
 Mat 3: green, pale blue, white mixed, yellow, black, brown/gold

- PVA adhesive
- Pencil
- Tracing paper
- Paintbrush
- Nippers
- Goggles
- Palette knife
- Cement-based grout
- Green acrylic paint
- Lint-free cloth or sponge

■ Template for the butterflies.

Working the design

Enlarge the template opposite using a photocopier so that it fits easily in the centre of the mat. You should leave enough room so you can fit a row of background colour in between the border and the butterfly. Then transfer the design onto the mat. You can do this using tracing paper as it does not matter if the diagram is reversed. Lay the tesserae out roughly to ensure that you have enough of each colour. Then remove the tesserae and seal both sides of the mat and the edges using a dilute solution of PVA (50% water, 50% PVA). Allow an hour for this to dry and then glue the tesserae in place by putting a dab of PVA on the back of each piece. It is easiest if you complete the butterfly first, then the green border and finally the pale blue background. Allow to dry for twenty-four hours and then grout following the instructions on page 35. When the grout is dry and has been cleaned, paint the edges of the tiles with green acrylic paint to match the border tiles. If you wish you can back the reverse with felt.

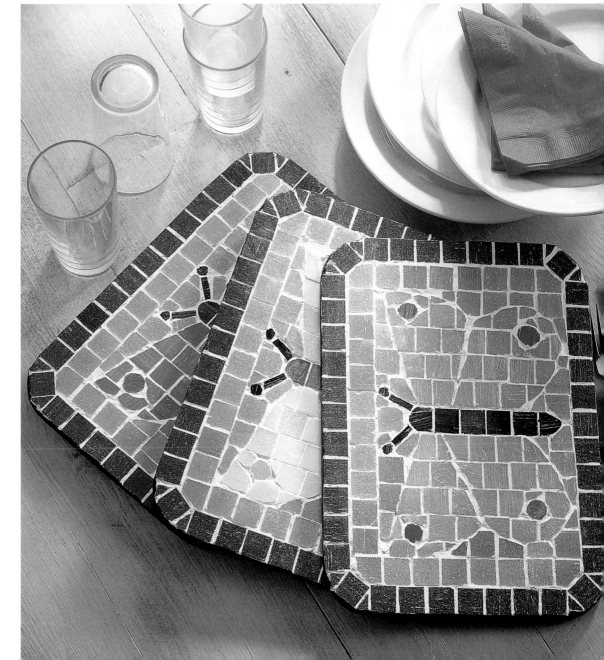

■ The butterfly placemats.

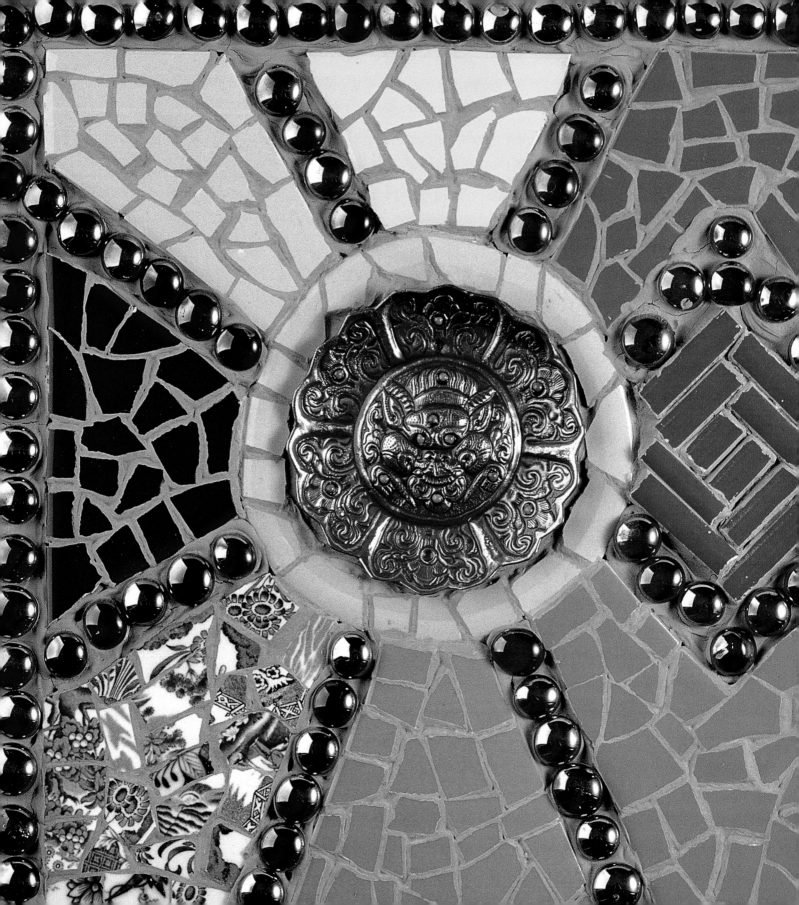

Project 18 · Wall plaque

Equipment needed

- Wooden board 16" × 23½" (40 cm × 59 cm) × ⅜" (0.9 cm) deep
- Two circular brass dishes (reasonably flat)
- Two plate rims to go around the brass dishes
- Glass nuggets
- Household tiles: navy, pale blue, mid blue, turquoise, yellow, orange
- Blue and white china
- Red tile edging for the centre
- PVA adhesive
- Paintbrush
- Cement-based grout and adhesive (coloured blue)
- Pale blue paint for exposed wooden sides
- Lint-free cloth or sponge

Working the design

The final design of your plaque will obviously depend on the size and shape of the brass dishes which form the focus of the design. The ones used for this project were saucer-sized and came from a jumble sale, but any shape will do as long as the base is flat enough to stick down firmly onto the wooden base.

Put the brass dishes on the base and divide the surrounding space into sections (see photo opposite for ideas).

Check you have enough of each type of tesserae and then prepare the board by sealing it with a dilute solution of PVA (50% PVA, 50% water). Any pencil markings you have made on the board will show through once the PVA solution dries. Following the instructions on page 34, stick the tesserae in place. Depending on the shape of the brass dishes, you may be able to stick them in place using epoxy resin. If the bases are very uneven you will need to use cement-based adhesive. Stick the plate rims, tiles and crockery in place using PVA. When this has set (allow twenty-four hours), grout the decorated areas following the instructions on page 35 using a grout and adhesive mix. This will enable you to stick the glass nuggets in place at the same time.

Allow the cement mixture to set and clean the tesserae following the instructions on page 35. Be careful not to dislodge the glass nuggets. Leave for twenty-four hours and then paint the exposed wooden edges the same colour as the grout-adhesive mix.

If you wish to hang the plaque, screw two small hooks into the rear of the board and fix strong wire between them.

History

The history of mosaics is particularly important and relevant to the present-day craft for two reasons – firstly the basic techniques have remained the same since the first mosaics were produced in ancient times and secondly we have available an almost unique visual history of the craft because such an enormous number of mosaics have survived.

Tesserae are much more varied now – plastic, paper and even dried fruits and vegetables can be used but the basic principle of placing small objects side by side to create a design has remained unchanged since the Mesopotamians made pebble patterns over 5,000 years ago.

Very little other artwork made in ancient times has survived which is what makes mosaics so special. The raw materials of mosaics were very durable (cement and solid tesserae) and many ancient mosaics were floors which were then protected when their surrounding walls collapsed on top of them.

Unlike many crafts, mosaics were originally confined to specific geographical areas. The craft was a popular form of decoration in pre-Columbian Central and South America and some early pebble mosaics have been found in China, but the bulk of historical

■ An ancient mosaic from Israel.

mosaics are to be found in the area surrounding the Mediterranean and in the Middle and Near East.

Even within these geographical boundaries the history of mosaics is not continuous as the craft suffered fluctuations in popularity, more so than other artistic techniques. The Greeks and Romans used mosaics extensively, as did the Byzantines in the Near and Middle East, but during the Renaissance the use of mosaics declined dramatically and in eighteenth-century Europe the craft only survived in a very specialized and detailed form, reproducing tiny copies of paintings, often no more than a few inches square but containing hundreds of minute tesserae.

At first sight, mosaics may seem an unusual and even impractical art form – frequently the same effects could be achieved in paint and areas of a single colour could be similarly achieved with larger pavings. However, mosaics are very satisfying to construct (or commission if you happen to be a wealthy property

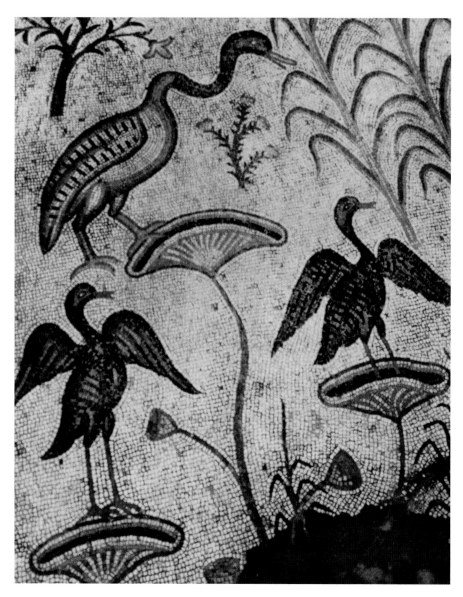

■ A Byzantine mosaic found near the Sea of Galilee – the heart of the mosaic-producing world.

reflected off them in a particularly attractive manner.

The earliest mosaics date from 3000 BC and are in Sumer, Mesopotamia, the area now covered by Iraq between the Tigris and Euphrates rivers. Two-inch cones with decorated ends were pressed into mud walls and created patterns in red, black and white. They are not considered true mosaics by some people as the tesserae or cones were not flat, but bearing in mind that almost anything can now be used to create a mosaic this seems a slightly restrictive definition. Mosaic objects have also been found at the Sumerian city of Ur and include drinking vessels and ornaments decorated with shell, bone, lapis lazuli and red limestone. The Standard of Ur can be seen in the British Museum, London and is richly decorated with stone, mother of pearl and shells.

Ancient Egyptians used stone inlay as decoration for furniture and walls and patterned pebble paths became popular in Chinese gardens, but the Greeks were the first people to use mosaics extensively. They began by making simple pebble floors but gradually the mosaicists added greater detail and variation by using painted pebbles. Increasingly cut stone pieces replaced pebbles since these allowed greater

owner) and they are durable to an extent far beyond any painting. This was an important consideration around baths and fountains where painted plaster would soon have disintegrated. Also, once glass and gold tesserae began to be used, mosaics became much brighter than anything available in frescoes. The mosaics could be easily cleaned and water and light

control over the design. It is known that mosaics were flourishing by the fourth century BC since many fine examples can be found at the ruined city of Olynthus in Northern Greece. This city was destroyed by Philip II of Macedonia in 348 BC and was never rebuilt, so anything surviving today must pre-date this time. Most of the mosaics were two-coloured (white or tan patterns on black, blue, green or red backgrounds) and may have imitated the popular red and black pottery of the day.

■ A simple design created using roughly cut stones.

From the first century BC onwards, marble and stone were increasingly used and as the patterns developed, small regularly cut pieces were necessary. It is at this point that the word tesserae becomes applicable, originally meaning a cube or four-sided piece of stone.

As fabrics and drawings from this period have not survived it is hard to tell where the ancient Greeks got the inspiration for their designs, but it is likely that a large number of them came from rugs. Many of the overall geometric patterns look like woven fabric and this would probably have been an important influence.

Pella was the capital of Macedonia and has examples of mosaics from c. 300 BC. They were mostly made of natural pebbles but the variations in colour were used to create patterns with many of the figures and details being outlined in lead. Some of these mosaics were very intricate and there is a famous example which shows two hunters attacking a deer. One hunter's cloak billows out wildly and the other hunter's hat has been blown off. Even the border of lilies and acanthus show fine detail.

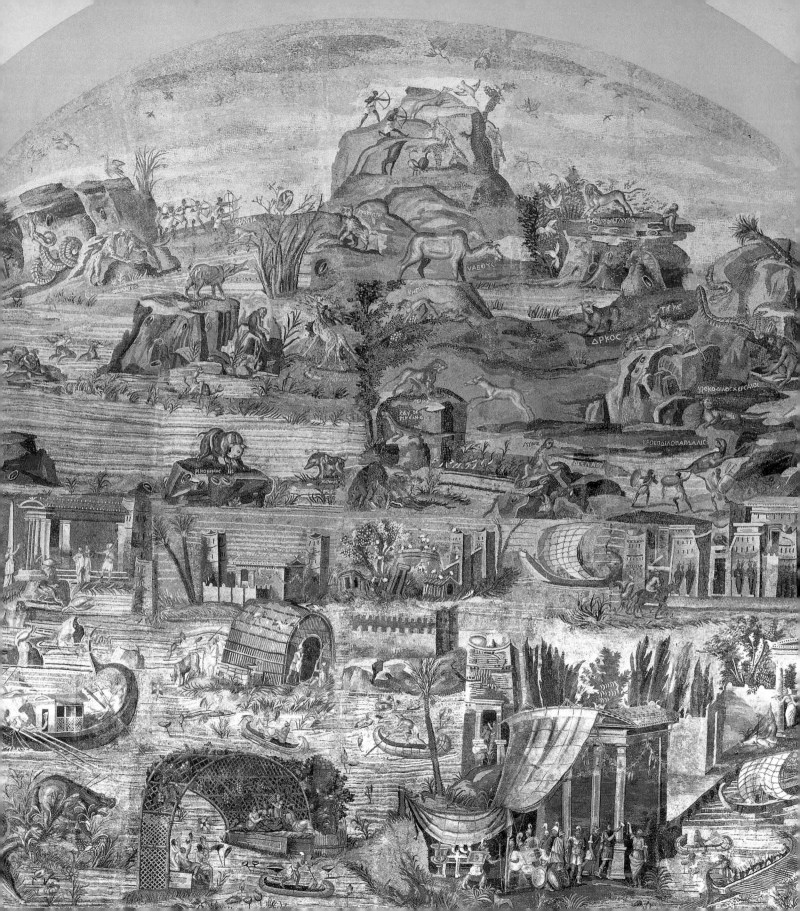

■ The simple pattern provides an attractive base for this ancient statue.

The Greeks were influential throughout the Mediterranean region and by the fourth century BC had established a base at Alexandria in Northern Egypt. Here they came into contact with Egyptian culture and achievements such as the pyramids impressed them greatly. In the first century BC a mosaic map was made showing the Nile from the Sudan to the Mediterranean. It was very detailed and depicted Greek villas, boats and feasts alongside

■ Left: Map of Egypt.

Egyptian temples, countryside and wildlife. Dragons and mythical beasts are shown in the areas beyond the Sudan which were still unknown at that time.

One of the most important and well-known towns from this era is Pompeii where almost everything was preserved under a thick layer of lava when Vesuvius erupted in AD 79. The town was part of the Roman Empire, but was originally a Greek village that gradually developed into a prosperous town. Many of the inhabitants of the town commissioned ornate mosaics – some for decoration, others to convey a message such as the popular 'Cave Canem' or 'Beware of the Dog!' (House of the Tragic Poet). Pompeii was a fairly crowded town and many of the houses had only small courtyards. Mosaics were cleverly used to give an illusion of greater space and small shrines with fountains became very popular. (House of the large fountain and House of the little fountain.) Mosaic floors were also used to mirror the ceiling above. This was particularly popular outside beneath pergolas where the mosaic depicted the pergola and vines above.

The Romans expanded mosaics onto walls and fountains and began using more glass and gold than the Greeks had done. Mosaic production was a costly and time-consuming art and is a good indicator of times of peace and prosperity. Until its decline in AD 300 the Roman Empire was extremely prosperous and, in the centre at least, relatively peaceful. The craftsmen were often itinerants who went where the wealthy patrons were and mosaic designs tended to be simpler and more geometric towards the edges of the Empire.

Detailed information regarding the production of mosaics has survived from Roman times. Vitruvius, the Roman architect of the first century AD, wrote a treatise on architecture which describes exactly how mosaics were made. The astonishing thing is that the method of production is exactly the same as that used today – the ground was levelled, then covered with a thick layer of pebbles, then a layer of cement and

■ Vines surround this man and his dog.

smashed bricks and finally a layer of cement and finely-ground bricks into which the tesserae were embedded.

As the wealth and stability of Rome increased so more mosaics were produced. Temples, baths, theatres, shops and even market places were ornately decorated. The increasing use of mosaics on walls as well as floors meant that finer tesserae could be used as they did not have to withstand the same pressure. The designs became more complex and pieces were usually only a ¼" (6 mm) wide. Glass could be used on walls and this allowed a wonderful palette of bright colours which were made by mixing minerals into the glass. Gold tesserae were made by putting a layer of gold on top of the glass cube and then sealing it in place with another layer of glass. Shells, wood and pieces of bone could also be used in wall mosaics, adding more variation.

The status of mosaicists in Roman times is uncertain but some must have reached a reasonable degree of fame as signed examples of work have survived. In AD 301 the Emperor Diocletian passed a price-fixing edict which listed all trades according to their worth. Mosaicists are listed as second-class tradesmen, below the other visual artists, but this may have been partly because much of the work involved in producing a mosaic was seen to be manual rather than artistic. By the following century the prices were split with workers on walls and ceiling being paid twenty per cent more in recognition of the increased risks they took – several mosaicists plunged to their deaths from the makeshift scaffolding which was used.

Most mosaics were produced by a team of people with a tessellarius cutting the pieces of stone or marble and a mosaicist cutting these tesserae into the exact shapes required. The ornate central panels were often made in workshops and then transported intact to the final site. These central panels were called *Emblema* and were often very ornate. They were also usually fairly small – their size dictated by how far the mosaicist could reach to place the tesserae. The Romans particularly liked images of nature or the world of the gods and these scenes usually surrounded the centrepiece which was often a detailed depiction of a god, emperor or even the wealthy patron who had commissioned the work. Julius Caesar took these portable slabs of mosaic with him on his military campaigns to decorate his tent. They had the double advantage of impressing the people he visited and were also considerably more hygienic than the rugs and skins which would otherwise have been used.

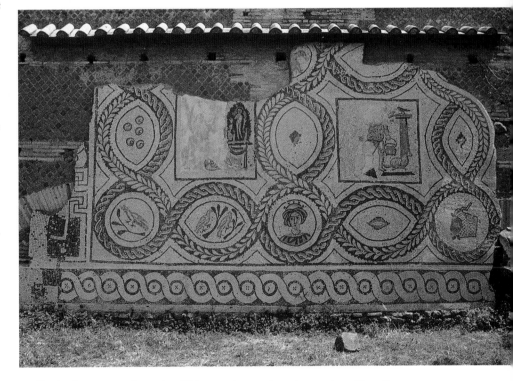

■ The intricate central panels of this mosaic may have been pieced together in a workshop and put in place when completed.

■ The layout of tesserae: *opus regulatum*, *opus tessellatum*, *opus sectile*, *opus vermiculatum* and *opus musivum*.

As mosaics became more popular, formal methods for placing the tesserae also developed. *Opus Regulatum* consisted of square tesserae lined up in rows similar to brickwork. This was frequently used for infilling backgrounds along with *Opus Tessellatum* in which the tesserae were aligned both horizontally and vertically. In *Opus Sectile* each tessera represented a single item, for example, a flower or leaf. *Opus Vermiculatum* was

the outlining of a shape and, finally, *Opus Musivum* was the continuation of this outline away from the object.

Another type of mosaic made popular at this time was the *Asaroton Oecon* or unswept floor (see page 87). It was in fact invented by the Greeks but gained huge popularity under the Romans. The background was usually white and was randomly scattered with objects, often representing the remains of a feast.

The Roman Empire always remained fairly diverse and the production of mosaics varied considerably within the geographical regions. In Britain and Northern Europe there was no tradition of mosaics before the Romans arrived but by AD 300 mosaic schools had been set up in most of the major provinces. In Britain geometric patterns of 3D illusions were particularly popular, as can be seen at Fishbourne in Sussex. Mostly local stone was used and as a result of this glass and gold are rare.

In North Africa there were a great many workshops and the designs here were a mixture of Roman and African, showing ancient mythology, sport and rural life. Depictions of gladitorial contests were particularly popular as were violent scenes like punishments and even executions.

At ports, such as Ostia near Rome, the different elements of the Roman Empire met and mixed. Here the mosaics were mostly made of black and white cubes and show scenes of ships, sailors and other harbours throughout the Empire. Maritime mythology was also popular especially Neptune and his trident.

Between AD 200 and AD 300 the Roman Empire developed serious problems politically and economically. People longed for a simple and peaceful life and many powerful Romans left the cities and retired to their country villas. They were still wealthy enough to commission lavish mosaics but these now frequently showed representations of philosophical ideals such as happiness and hope or more natural events such as the cycle of the seasons. A large villa in

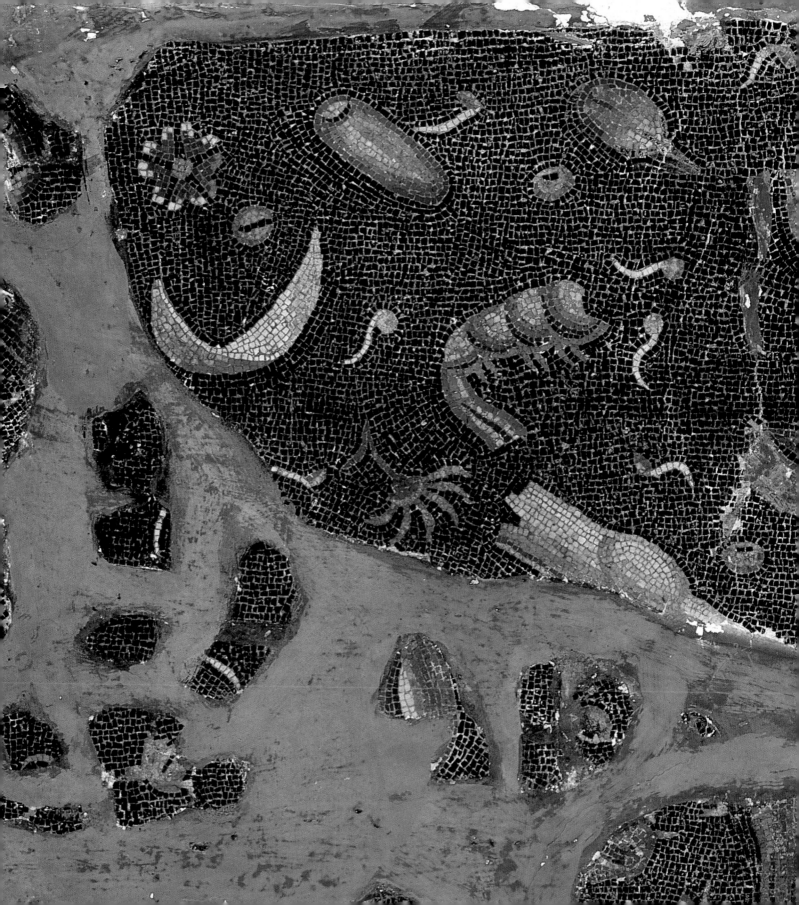

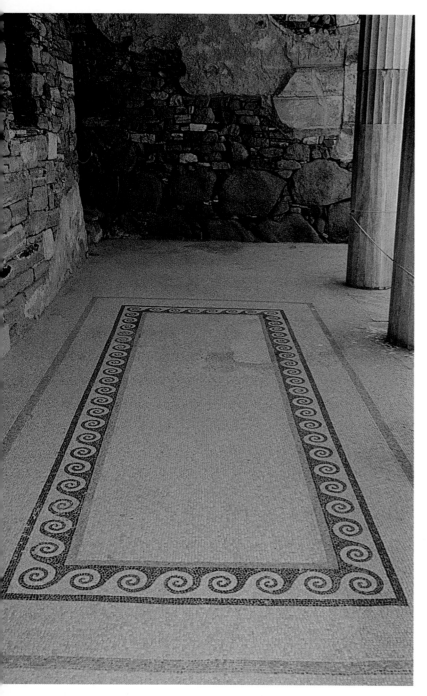

An effective pattern of waves in black and white found in Greece.

Previous page: Unswept floor.

Sicily, probably owned by Herculius Maximinus, contains mosaics showing chariot races in the colours of the four seasons (white for winter, blue for spring, green for summer and red for autumn). The mosaics in his house also depict a portrait of himself and scenes of daily life such as bathing and arriving home, greeted and attended by servants.

In AD 300 invaders from the North attacked Rome and Byzantium became the more important city. In AD 330 it was made the capital of the Empire and was rebuilt as Constantinople. In AD 337 Emperor Constantine died and the Empire was split, but whereas the Western Empire collapsed the Eastern survived for nearly a thousand years. This Eastern Empire included the Holy Land where the major religions of Christianity, Judaism and later Islam all had their centre. These religions were all wealthy and it was in their churches, temples, synagogues and mosques that mosaics flourished. Religious rules governed the artistry but these restrictions created variations rather than limitations. Jews were not allowed to depict living beings until the third century AD and the same rule applied to Christians until the fifth century and the Muslims until the present day. Within these restrictions mosaics tended to consist of ornate geometric patterns, but once the ban was lifted the telling of stories in pictures became very popular, mainly because it was an easy way of conveying the Bible stories to an illiterate population. In Northern Israel there is a mosaic pavement showing two fish and a basket of loaves reputed to be on the spot where Jesus is said to have performed the miracle of the feeding of the five thousand (see opposite).

Constantinople became famous for its architecture, decoration and mosaics. The Hagia Sophia (or Holy Wisdom) was completed in AD 537 and became one of the most important churches for the Christian faith. Glass, silver and gold tesserae were extensively used but now they were not smoothly polished. The uneven surface reflected both natural light and candlelight and mosaics became works of art rather than functional objects. The golden sky in the vaults

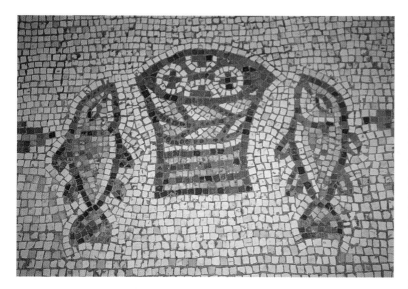

■ The mosaic pavement marking the spot where the feeding of the five thousand was reported to have occurred.

coast of Italy and was already wealthy before it gained political status. Many beautiful churches and mosaics were constructed and although the town was conquered by the Byzantine Empire in the sixth century the governors who lived there for the next 150 years continued the tradition of artistic patronage. The sixth century church of Apollinaire, the patron saint of the city, has mosaics showing Jesus and Mary surrounded by saints in fields of lilies and palm trees. The church of St Vitale, built just after, has mosaic panels showing the Emperor Justinian and his wife Theodora both with haloes, against a rich gold background.

While church patronage encouraged lavish works of art, mosaics were still used by everyday people. The tradition of decorative cobblestone floors has survived continuously up to the present day. Many poorer

and domes consists of 150 million golden tesserae and over 1,000 tons of glass. In the fifteenth century the Ottoman Turks conquered the Byzantine Empire and converted Hagia Sophia into a mosque. The mosaics which depicted people were regarded as idolatrous and were covered with plaster but ironically this actually protected the mosaics and in 1935 they were uncovered and the church opened as a museum.

Gold had been used by the Romans to represent supernatural light, for example, haloes – but it was now used extensively as a background with the tesserae angled to reflect the light. The wealth of the church made this possible and churches such as St Mark's in Venice became a riot of colour and light. Skilled workmen often travelled thousands of miles, for example, the Great Mosque of Cordoba in southern Spain was built with materials and workmen from Constantinople.

Although the Western Empire did not survive as long as the Eastern, it did not collapse immediately and in AD 402 the capital was moved from Rome to Ravenna as it was felt to be safer. This was a port on the East

■ This mosaic of Jesus in the Hagia Sophia shows how effectively the Byzantines used gold tesserae.

■ Left: Turquoise pectoral ornament in the form of a double-headed serpent.

churches had pebble floors, but these often had attractive designs including signs of the zodiac or old legends.

At this time a different type of mosaic art was flourishing on the other side of the world in pre-Columbian Central and South America. Here small portable objects were decorated rather than architecture. Masks were made with turquoise, jade, coral, mother of pearl and shell and small items such as mirrors and jewellery were also ornamented. A much greater range of tesserae was used compared with the West but the techniques were still the same, with the pieces being attached to the base (baked clay, leather, wood or stone) with a sticky substance made from plants known as pitch. The most famous examples are the bright turqoise mosaics (in the British Museum) in which the tiny tesserae are cut with flints. Masks were also very popular using white shells for eyes and teeth and feathers for decoration.

In Europe the Renaissance led to the rise of painting as the most popular art form. Durability was no longer so important and techniques in art had advanced faster than those of mosaics. Paintings were easier to accommodate, often cheaper to produce and quickly came to be regarded as a finer form of art. However mosaic schools continued to flourish especially in Italian cities such as Florence, Venice and Rome. The important shift was that mosaics were now used to imitate paintings and this meant that a much greater range of colours was necessary – at one time the Vatican workshops produced over 27,000 different colours of smalti. Micromosaics were also produced, again frequently copies of paintings. These consisted of thousands of tiny pieces – up to 1,400 per square inch – but while they were undoubtedly technically brilliant they were really the work of a fine artist rather than a mosaic craftsman.

■ Klimt's frieze for the Palais Stoclet in Brussels.

In the nineteenth century the emphasis shifted again and concentrated more on restoring or imitating ancient mosaics. The Imperial School of Mosaics in France was set up purely for this and no new work was encouraged at all. Throughout the nineteenth century these large, specialist schools continued producing mosaics, many of which were attached to sheets of paper and shipped abroad, for example, some of the mosaics on the Albert Memorial in London were made in workshops in Venice. Glass was now produced industrially so the costs were greatly reduced, but in many cases the spontaneity and individuality of the

piece was lost. Gradually during the nineteenth century, in Europe particularly, there was a revival in crafts and decorative techniques and movements such as Art Nouveau became important. Within this movement mosaics had a major role and as a result their popularity increased and they were used to decorate relatively ordinary buildings as well as the grand public commissions such as St Paul's Cathedral in London and the Paris Opera. For almost the first time in history important popular artists became interested in mosaics and mosaic-like effects. Chagall, Klimt, Kokoshka and Braque all made cartoons for mosaics and Leger actually designed and produced his own.

Many of Klimt's paintings have a mosaic-like quality and he designed the fabulous mosaic of semi-precious

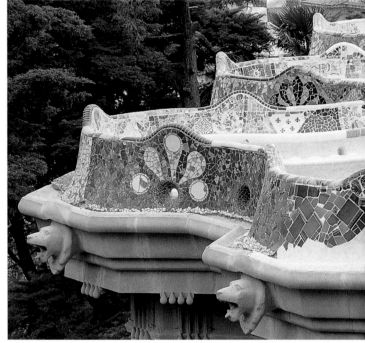

■ Parc Guell, Barcelona.

stones and enamels at the Palais Stoclet in Brussels. All these artists helped the renewed fortune of mosaics but none more so than Gaudi (1852–1926), a Catalan architect and designer who worked primarily in Barcelona, Spain. He probably had the greatest influence on mosaics today and was the first mosaicist in Europe to use the technique of decorating 3D objects to its full potential.

Gaudi's most startling achievement was probably the Parc Guell in Barcelona. Here huge park benches, columns and fountains are decorated with old china, broken tiles and pieces of glass. Not content with this he also decorated roof tops and chimneys – in fact almost any available surface. This was a completely different view of mosaics from the fine church pieces of industrially produced panels and had an immediate appeal. Here, finally, was a craft anyone could

■ Mosaic façades, University Mexico City.

participate in and enjoy. Nowadays mosaics like this can be seen all over the world, from porcelain-covered temples in Bangkok to private back gardens and grottos, but at the time it was a completely new departure. Very few people could aspire to decorating the inside of a great palace or cathedral, but anyone could stick broken china onto a garden wall or bench. Suddenly mosaics had an appeal for everyone – not just the rich patrons or fine craftsmen.

Now there are no restrictions regarding what can be produced. A good example of the eclectic approach to making mosaics is the home of a French workman called Raymond Isidore (1900–64). He lived in a cottage near Chartres which had been built in 1929. He spent over half his life decorating the cottage and its garden with anything and everything. Interiors and

exteriors were decorated with shells, pebbles, broken tiles and old crockery. His neighbours christened the house 'Maison Picassiette' – the name being a variation of *Pique-Assiette*, literally a scrounger, but used to refer to mosaics predominantly made of broken china and glass.

As the history of mosaics shows, the scope for mosaic-making has opened up enormously over the centuries. Once only the province of the artist and craftsman, now anyone interested enough can try their hand at projects ranging from the simple and straightforward to the more elaborate and involved. It is possible for people to borrow ideas from any historical period but at the same time to make use of more modern techniques and the huge variety of tesserae that are now available.

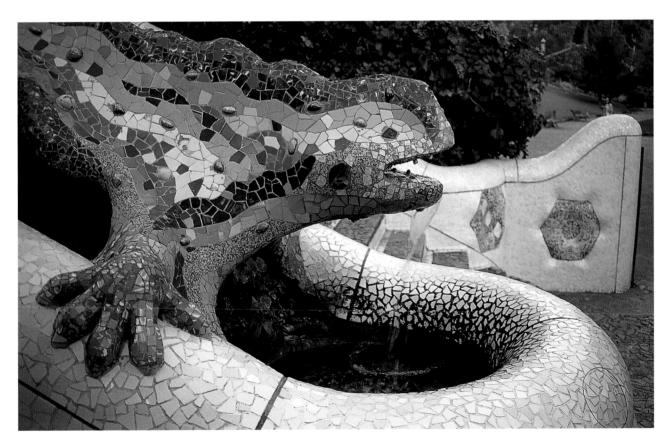

■ Parc Guell, Barcelona. Tiled lizard fountain.

10

Design and inspiration

If you decide to design your own mosaic, there are various important considerations you need to think about before you begin. Somewhat surprisingly the first decision you have to make has nothing to do with the actual construction of the mosaic itself. You need to decide what type of object you wish to decorate, what its function, if any, will be and where it will live.

■ A mosaic design on a marble floor.

Small and large objects have very different requirements in terms of design, for example a large object may be viewed from far away whereas a smaller one may be looked at more closely and may involve more detail. This does not mean that you have to complete the smaller object with more care, but that you have to consider what type of decoration would work best when viewed from close quarters. Fine detailed work is usually better seen close to, whereas the smaller details are often lost in a mosaic which is viewed from some distance. Large sweeping designs are unsuitable for small projects and on a big area too many changes in colour or intricacies of pattern can make the finished project appear confused.

To a certain extent the object you have chosen may decide for you how it should be decorated. Much of the advice and information that follows really only applies to largish flat expanses such as bath panels, screens, table tops, etc.

Having chosen what to make you then need to decide what, if any, its function will be. As before, with some objects, for example, garden containers, this will be obvious, but for other things it can be an important consideration. How hardwearing does the finished mosaic need to be, does it need to be waterproof and if so to what extent, for example, will it regularly be soaked in water, like a shower surround, or merely dampened occasionally, like a table top?

Having given some thought to the function, you then need to decide on the setting for your mosaic. Some objects, such as trays, will move regularly but most will have a permanent home and it is important that they look their best in it. A mosaic which is in a dark corner may need to be considerably brighter than one which is seen in direct light. Its position will also affect the angle at which it is viewed. Will people look up at it or down onto it, does it have a front and back or does it need to look good from all angles?

You need to take into account the light source for your mosaic and whether it will be primarily seen by day or night. It is no good constructing your mosaic so it looks marvellous in the bright light of a studio, if it is only ever going to be seen in the subdued lighting of a small table lamp. This is not to suggest that you should construct your mosaic in a poor light, but that you should take the matter into consideration when you think about the colours, materials and design.

The final decision you should make at this stage is whether you want your mosaic to complement its surroundings or stand out from them. Do you want something that will blend in with the rest of the room or something that will be noticed immediately and provide a focal point? If you go for the latter option, be careful to ensure that your mosaic is striking without clashing unpleasantly with its surroundings.

You now need to decide how much you want to spend on your mosaic both in terms of time and money. Using objects you have collected yourself and broken crockery is a very cheap method of acquiring tesserae, while at the other end of the scale, smalti and gold and

■ A geometric design using square tesserae and a random pattern using different shapes.

silver tesserae can work out to be very expensive. Ceramic tesserae and smalti are fairly consistently priced but vitreous glass tiles vary enormously with sheets of pink tiles costing four times as much as those in swimming-pool blue. In terms of time, be realistic about how long you want to spend making your mosaic and choose your design accordingly. Simpler designs usually work better anyway but even in the most straightforward of designs awkward curves can lead to hours of fiddly cutting. Geometric designs using whole tesserae are obviously the quickest to make and random placement of pieces can also be easy as it does not usually matter what shape your tesserae are.

In theory, all the above decisions should have been made before you decide on a pattern or design, but in reality you will probably have been inspired by

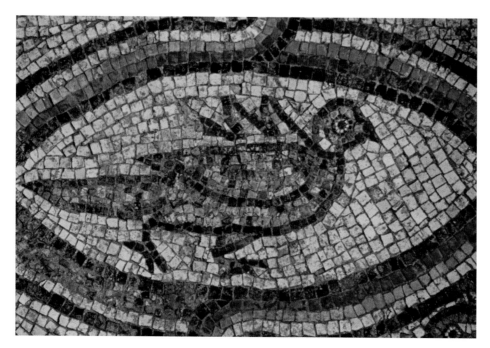

■ Detail taken from an ancient mosaic.

something long before taking any of the practicalities into account.

The inspiration for mosaics can come from almost anywhere. It may seem pretentious to carry a sketch pad with you at all times, but a small notepad can be invaluable and you should not feel inhibited about using it to make a note of anything that fires your imagination. Colour combinations or patterns which you particularly like are very easy to forget, especially if you do not start to design your mosaic until some time later. Historical mosaics are an obvious starting point and a selection of interesting places to visit is given on pages 110–111. Many historical mosaics in churches and temples were constructed by skilled craftsmen over a number of years but often you can take a small part of a mosaic and use an idea just from that one area.

Equally, you can copy a design, but execute it in different materials. For example, simple Roman geometric floor mosaics in black and white can look lovely if copied in brilliant glass tiles.

Books, magazines and museums are also excellent sources of ideas. Some examples are listed on pages

■ A simple design in a variety of colour combinations.

■ Part of a stained-glass window which could easily be transformed into a mosaic.

110–111. The books in the Dover series are particularly useful as they cover a very wide range of subjects. Do not just look at mosaics, but anything where colours and shapes interact. Patchwork quilts and stained glass both use some of the same ideas as mosaics and can be good starting points for ideas.

Do not try to copy anything exactly (unless you particularly want to) but take the elements you like and use them in combinations of your own.

Nature can provide great inspiration both in terms of colours and shapes. A visit to a zoo or garden can trigger off ideas and grander schemes, such as mountains or oceans, as well as tiny details from the natural world can be incorporated into mosaic design.

Traditionally mosaics covered only a small area geographically, centred on the Near and Middle East and Central America, but they can now be found all over the world in many surprising shapes and forms. If you wish to give your mosaic the feel of having come from a certain historical period or geographical region, this is easily achieved by using typical motifs. Stars, crosses and geometric designs will tend to give the piece a religious or classical feel, as will the use of pebbles, stones and smalti.

Animals, birds and the sun executed in jade, turquoise and pieces of ceramic will apppear Mexican. For

Islamic mosaics geometry, plants and lettering are important, usually made in marble, ceramic tiles or smalti with gold and silver to give brilliance. Images of the East can be conjured up with the use of symbols and designs from astrology and myths and legends or eastern animals ranging from dragons to elephants. To create a modern effect, use abstract designs and the whole range of tesserae from broken crockery and beads through to tiles and smalti.

Having decided on an idea, it is worth making a rough sketch to check that your idea works and can be converted into mosaic. You do not need to be a great artist to complete a rough sketch – it is only for your own use and all that matters is that you feel inspired by it and find it useful. Cartoons (life-size paintings) can be useful if you are working in great detail on a large scale but they can be daunting and are by no means vital and, in some cases, the work will be more interesting and spontaneous if some of the details are worked out as you go along.

Before you decide what tesserae to use, look carefully at what you already have. Each type of tesserae has different qualities both in terms of practical and artistic usage: broken crockery offers endless possibilities, smalti have amazing reflective properties and vitreous glass tiles come in an excellent range of colours. Gold and silver tesserae seem very expensive but in most cases a little goes a long way and a few well-placed tesserae are all you need.

Once you have chosen your basic design there are a number of ways in which you can adapt it. In mosaics the most obvious medium for variation is colour and it is useful to know a little about the various colours and how they react with each other.

It may be sufficient to decide that you want a red and blue mosaic, but the finished result can clearly vary

considerably according to which reds and blues you use. Each colour can be described in terms of hue, tone and intensity and it is these factors which largely determine how colours interact with each other.

Hue describes the colour itself, i.e. the redness, blueness, etc. Black, white, brown and grey are all neutral colours with no distinct hue. The hue of a colour decides its position on the colour wheel. There are said to be 150 different hues, but the most important are the primary colours which are red, blue and yellow and the secondary colours, which are made up of mixtures of the primaries and are violet, green and orange.

Tertiary colours do not always appear on the colour wheel and are further mixtures of primary and

■ Fabric like this from Guateamala could be the inspiration for a mosaic design.

■ These tiles from the silk road are instantly recognisable as Islamic work.

■ The colour wheel.

secondary colours, for example, turquoise, lime, yellow-orange, orange-red, crimson and violet-blue.

The use and understanding of colour is particularly important if you are using vitreous glass tiles, or smalti, where there is a wide range of colour. The Byzantines understood colour very well and this is one of the reasons why their mosaics are so effective.

Johannes Itten at the Bauhaus devised the seven colour components in the 1920s which explain how colours can be used, some of which are applicable to mosaics. Not all are relevant as, unlike paints, the colours of tesserae cannot be mixed. The intensity of the colour is also important as it determines its strength. If it is maximum saturation or intensity the colour is strong, bright and clear. Minimum intensity results in muted colours. More intense colours will always stand out, they need not be dark but they will give the appearance of a solid mass of colour. Some colours, particularly blues or greens can appear more or less intense depending on the colours which surround them.

■ The orange square appears more intense than the green one which tends to recede.

To a certain extent this applies to all colours but brilliant yellows, oranges and reds will always tend to stand out more as they are the most intense colours.

Tone describes the lightness or darkness of a colour. Taking hue to be the pure colour, shades are darker tones and hints are paler tones. The colours on a colour wheel can also be described in terms of tone with yellow being the lightest and violet the darkest. Red and green have the same tonal value which is why they frequently appear the same on a black and white photograph. Colours of the same tones will always tend to merge together if seen from a distance. This is particularly so of blues and greens.

■ Different tones of blues and greens above compared with similar tones below.

■ Dark and light tones of blue.

A point to beware of is that using close tones in dark colours can result in too little contrast. Using the same theory, strong outlines can be created by placing two different tones of the same colour next to each other. By doing this the light and dark of each colour will be emphasized.

Sharp outlines can also be created by using lighter shades of complementary colours (see below), for example, pale orange and dark blue.

The next important aspect of a colour to consider is its coldness or warmth. The right-hand side of the colour wheel is usually warm and the left-hand side cold.

This can vary slightly according to the surrounding colours, for example, crimson is warm compared to blue but cold compared to orange.

If made on a large scale, mosaics can be used as part of interior decoration to create warm or cold areas. On the whole warm colours, such as red, orange and yellow, stand out whereas cold ones, such as blues and greens, tend to recede. Because of this warm and cold colours are also referred to as advancing colours and receding colours.

Complementary colours are found opposite each other on the colour wheel, each one consisting of a primary and secondary colour, for example, red and green, yellow and violet and blue and orange.

■ Warm reds and oranges next to cold blues and greens.

■ The complementary colours of the colour wheel: red and green, yellow and violet and blue and orange.

The reason they complement each other is that each secondary colour is made up of the other two primary colours, for example, green complements red because it is made up of a mixture of blue and yellow, the two remaining primary colours. When seen close up, complementary colours appear bright, whereas seen from a distance they tend to merge to form grey. Maximum contrast is achieved by placing a primary colour and its complementary colour next to each other. Complementary colours of equal intensity and brilliance seem to flicker when placed next to each other. If this is too pronounced it could detract from the overall pattern of a mosaic. When you look at one colour very hard and then look at a sheet of white paper, a dot in the complementary colour will appear. This is because your eyes are trying to compensate for

an overload of one colour. It can look very effective if small quantities of the complementary colour are added, but if the colours are used in equal amounts problems can arise as the eye cannot focus on both equally. The natural eye will tend to see complementary colours even if they are not there (this is not so with cameras). If a natural grey grout is used to surround an orange mosaic the grey will appear to have a blue tinge.

The most important thing to remember is that colour is always influenced by its surroundings. This is why it is so useful to lay your tesserae out first and to have taken into account the mosaic's final position.

It is also important to decide how many colours you want to use. Too many colours can end up looking confusing and many of the most effective mosaics are simply made in black and white or two colours. Unless you are trying to reproduce a particular object accurately, such as a human face, the safest rule to follow is, 'if in doubt, simplify'. Large areas in a single colour are perfectly acceptable; in fact they will probably emphasize the patterned area which would be lost if there was a lot of variation in the background.

An important point to bear in mind when looking for inspiration from colours is that not all colours transpose well from their original setting. Light, styles of furniture and buildings can all alter the appearance of a colour. In hot climates intense colours look lively and bright in the strong light. The light in temperate climates is kinder to softer, muted colours and bright colours can look garish. Equally, muted colours can look dull and murky in the bright light of areas such as the Tropics.

After the tesserae themselves, the grout is the most important thing to consider. Not all mosaics are grouted, indeed smalti cannot really be grouted satisfactorily, and ungrouted mosaics frequently appear brighter as the colours of the tesserae are not muted by a single overall surrounding colour.

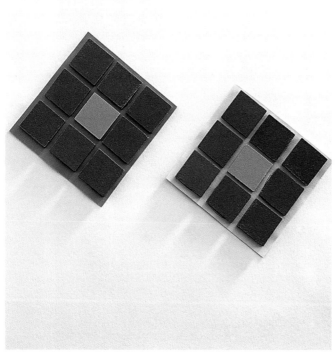

■ Different coloured paper can be used to represent coloured grouts.

The traditional view is that the colour of the grout should match the overall tone of the mosaic, for example, if it is very dark the grout should be dark and if the overall feel of the piece is pale the grout should be a pale tone or white. White can be very stark, so if you want a softer effect you should slightly tint the grout so it is off-white or ivory.

When you are laying out the tesserae to plan a design remember to take into account what colour grout you will use. One way to do this is to lay the tile out on different coloured sheets of paper. This will obviously not look the same as grout, but it will show you what different contrasts you can create. See photo on page 102.

Remember that because of the nature of its consistency it is quite hard to get very brightly coloured grout. It is also possible to work out what designs you want by using different permutations in paint and on paper, but this is not always satisfactory as it is extremely hard to get paint on paper to look exactly the same as tesserae surrounded by grout.

The effect of the grout will also vary with the type of tesserae used. Ceramic mosaic tiles are usually matt and come in a range of muted colours. They tend to emphasize the grout in between the tiles whereas vitreous glass tiles are shinier and usually stand out more than the surrounding grout.

Apart from the colour of the grout, the width of it is also important. If the tesserae are placed very close together, the design will stand out more whereas if the tesserae are placed further apart they will appear to float on a sea of grout.

The texture of the tesserae will influence the finished appearance of the mosaic. Unglazed ceramic and marble are matt and absorb light. Glazed ceramic, mirror, gold and most crockery are reflective to varying degrees. To realize their greatest potential, reflective tesserae often need to be laid at an angle so that they will catch the light. The Byzantines were particularly adept at this as can be seen in churches like Hagia Sophia in Istanbul.

■ The appearance of a pattern can change according to the width of the grout.

Surface interest can also be created by varying the height of the tesserae. This is obviously only possible on mosaics which do not need to be flat but it can create interesting shadows and areas of light and dark.

Using certain materials it is also possible to vary the size of your tesserae. Small pieces are ideal for detailed work, whereas larger pieces are good for infilling background areas.

Conversely large pieces can form the central design and be surrounded by a variety of tiny tesserae.

Most tesserae that you find yourself will be randomly shaped, but specialist mosaic tesserae can be used in three ways; either as they are, cut into geometric

■ Interesting patterns can be created by varying the size of the tesserae.

shapes or cut into random shapes. In reality most mosaics are a mixture of all three. For the central design or pattern the shapes of the tesserae will be decided for you by the design, but when it comes to the background you have several choices as to how it can be infilled.

Random placement of tesserae to fill in backgrounds is very popular but it is important to realize that random placing is rarely quite as haphazard as it might seem. It is particularly important when filling in a large area to ensure that the colours or textures are equally distributed around the whole. It is often worth dividing the area into sections and then sorting your tesserae into the same number of groups. This also has the advantage of ensuring that you do not run out of a particular colour.

Straight lines or *opus tessellatum* provide a formal background, but it is important that all the tiles are aligned exactly, both horizontally and vertically, as any irregularities will stand out. It is also important that all the grout spaces are even. *Opus regulatum* consists of

offset tiles in horizontal rows and is often easier to fit around a design as the placement of each row of tiles varies.

■ *Opus tessellatum.*

■ *Opus regulatum.*

A central motif can be emphasized by *opus vermiculatum* by which the motif is first outlined by a row of tesserae in the background colour. (The term *opus vermiculatum* means worm and describes the way the tesserae worm their way around the outline of the central motif.)

■ *Opus vermiculatum.*

In *opus musivum* this outlining is continued right to the edge of the mosaic. When using this method it is very important that each successive line follows exactly the curves of the previous line.

■ *Opus musivum.*

Fans working their way across the background can be effective but, again, need to be placed very exactly.

Swirling lines or the use of a variety of shades of a single colour can be used to create an effect of movement. (See the tray project on page 54). This is a device commonly used in swimming pools to emphasize the movement of the water. Be careful that the variations in colour do not detract from any central pattern.

■ Fans can be used to create a striking background.

A different type of mosaic design is the accurate reproduction of an object such as an animal or the human face. This type of mosaic was most common in historical times and can be seen in churches across the world, for example, Ravenna and San Marco in Venice. Here slight variations in tone and colour are particularly important and it is worth painting a cartoon (life-size plan) as the placing of pieces can vary dramatically with size. What may have looked fine in a nine inch square drawing may not look so accurate in a nine foot square panel. You are almost bound to need to alter the size of the original design you intend to copy. You can reduce or enlarge it on a photocopier or by using a grid.

To do this you must draw an accurate grid over the original (see overleaf). Make sure you place the lines close enough together so you can easily copy the shapes within each square (1" (2.5 cm) is usually a good distance). Then count the squares and draw a grid the correct size for your project. For example, if you needed to double the size of the original, each square would become 2" (5 cm) square. It is then easy to enlarge the original by copying each square onto the new grid. The positioning of individual tesserae in areas such as faces and hands is particularly important – the alteration of a single tessera can change the feel of the whole piece. Designs of animals and birds can have the same problems, but here human preconceptions frequently make things much easier. For example, anyone would recognize a four-legged animal with a hump as a camel even if in other respects it was not an accurate representation.

mosaics

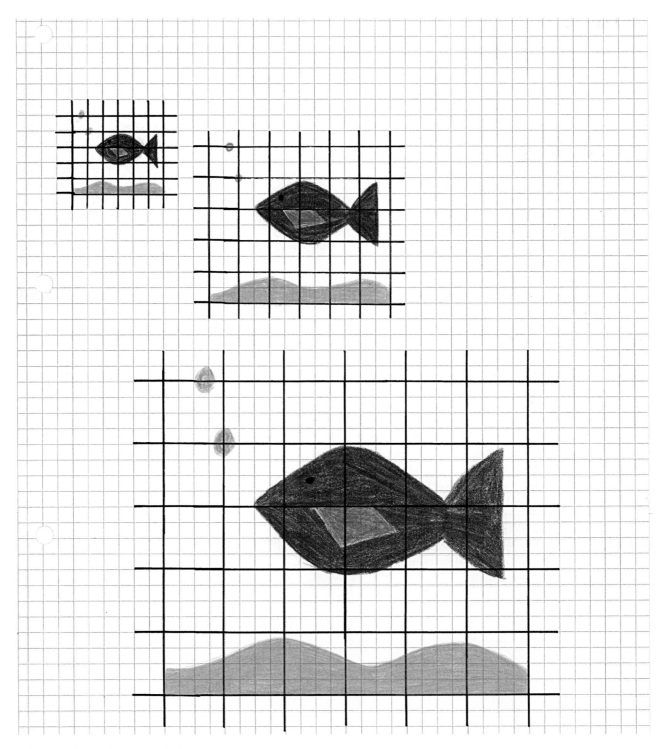

■ Enlarging and reducing designs using a grid.

Finding ideas for your mosaic and designing it yourself can sometimes be the most interesting and exciting part of the whole process of mosaic-making. With a bit of knowledge, you can design an object to suit your own tastes and needs. Once you have started making mosaics you will probably find that your inspiration comes from a huge variety of sources. Try to be as inventive and uninhibited as you can with your ideas, without being overly ambitious. What you decide to make can be as original or as conventional as you like.

■ This picture could be used for a mosaic design.

Glossary

Acrylic paint Water-based paint which can be used for colouring grout. Also suitable for touching up small areas of exposed base. Will adhere to most surfaces.

Advancing colours *See* **Warm colours**.

Andamento The arrangement of background tesserae so they appear to 'flow' across the mosaic. Can also be used to describe the lines of grout across the mosaic.

Basilica Used in Roman Catholic and Greek Orthodox religions to describe a church of particular importance either in terms of antiquity or religion. In architecture it is usually used to describe rectangular buildings with an open hall running from end to end, side aisles separated by colonnades and a raised platform at one or both ends.

Bolster blade *See* **Hardie**.

Buttering Spreading a small amount of adhesive onto the back of each tessera separately, i.e. like buttering a piece of bread.

Calcined The process whereby lime and clay are burned at high temperatures (1500°C) and then ground to produce cement powder.

Cement Made by calcining lime and clay. When mixed with sand and water it can be used as a mortar for mosaics.

Cement-based adhesive Available in powder or ready-mixed form. Can be used for attaching most types of tesserae to most bases. See section on adhesives for further details.

Cement dye Available in powder or liquid form. Used to colour cement.

Ceramic tesserae Small glazed or unglazed tiles specially made for mosaics. The term can also include household tiles and broken crockery.

Cold colours Those on the left-hand side of the colour wheel, most commonly blues and greens. They have a tendency to recede when used in a design.

Complementary colours Each primary colour has a secondary colour opposite it on the colour wheel which is its complementary, for example, red and green. They can appear bright when placed next to each other. The impressionists had a theory that the complementary colour appeared in the shadow of a primary colour, for example, the shadow of an orange object would appear blue.

Concrete A mixture of sand or gravel bonded together with cement and water.

Cosmati work Mosaic designs originally made by the Romans (*Opus Romanum*) consisting of geometric designs with areas of small tesserae interspaced with areas of larger plain slabs of stone. Originated in Arabia and came to Rome via Sicily. The Cosmati family specialized in this type of mosaic. A good example of cosmati work that can be seen today is the magnificent cosmati floor in Westminster Abbey, made in 1268.

Cure The process whereby cement-based adhesive or grout sets firm.

Emblema (plural – emblemata) Central pictorial panel often found in Roman mosaics. Frequently very intricate, these panels were completed in a workshop and then set into the mosaic on site.

Epoxy resin A strong adhesive which comes in two parts (adhesive or resin and hardener) which are mixed together immediately before use. It is suitable for most surfaces. For more detail see section on adhesives.

Filati Mosaic glass which has been pulled while in a molten form into long threads. These are then cut to form tiny tesserae used in micro mosaics.

Float Builder's tool for flattening cement.

Grout A mixture of cement, sand and water used to fill the gaps between tesserae. Can be bought ready-mixed.

Gum arabic Water-based adhesive used in the indirect method to stick the tesserae to paper.

Hammer and Hardie Traditional tools for cutting smalti and marble. The tesserae are placed on the hardie (an anvil embedded in a solid base) and broken when hit with the hammer.

Hue Describes a colour, for example, redness, blueness. Determines the colour's position on the colour wheel.

Hint Used to describe paler tones of colour.

Intensity This is the strength or brightness of a colour. It need not be dark but an intense colour will appear as a solid mass of colour.

Key Roughness on a smooth surface to allow adhesive to grip.

Lint-Free Cloth Cloth with no woollen fibres which could catch on the mosaic surface. Old shirts or cotton sheets can be used.

MDF Medium Density Fibreboard.

Micromosaics Mosaics made from tiny tesserae, often with over 1000 per square inch.

Mortar A mixture of sand, cement and water.

Neutral colours Black, white, brown and grey, i.e. colours with no distinct hue.

Nibbling Cutting away small fragments of tesserae using nippers to produce a required shape.

Notched float (also **serrated float**) Similar to a builder's float but with a notched edge for smoothing and keying a cement base.

Opus musivum Lines of tesserae radiate out from the central design following its outline. This is one of the more sophisticated methods of background infilling and literally means 'pertaining to the muses'. It is usually found on wall mosaics.

Opus regulatum Rectangular tesserae are arranged in straight rows in a staggered pattern similar to a brick wall.

Opus romanum Geometric shapes of tesserae are used. *See also* **Cosmati Work**.

Opus sectile The tesserae are cut so that some of them form individual objects, for example, leaves. All the tesserae are cut into exact shapes and the finished design frequently looks like an oriental carpet. Popular in the fourteenth and fifteenth centuries, with examples in St Mark's Venice and SS Maria e Donati on Murano.

Opus tessalatum Square cut tesserae arranged in horizontal rows. The tesserae also line up vertically giving a very regular background. Most commonly used for backgrounds on floors.

Opus vermiculatum A line of irregular tesserae follow the outline of the main design creating a halo effect.

Palette knife Craft knife with a short flexible blade. Blunt kitchen knives will often do just as well.

Pizza (plural – Pizze) Oval-shaped slabs of molten glass which are cooked and broken into smalti.

Plywood Wood which is made up of several layers. Three- or five-ply is usually the most suitable as a mosaic base.

PVA (Polyvinyl Acetate) A white craft adhesive which is easy to use and dries clear. For more detail see section on adhesives.

Primary colours The three main colours on the colour wheel, i.e. red, blue and yellow. They cannot be produced by mixing any other combinations of colours.

Receding colours *See* **Cold colours**.

Reinforced concrete Concrete which is strengthened by having metal or wire embedded in it.

Secondary colours Colours which are produced by mixing primary colours, i.e. violet, green and orange.

Shade Term used to describe darker shades of colour.

Smalti Traditional mosaic tesserae made in Italy. The glass is melted, treated and allowed to set in irregular discs or pizze. These are then broken up to produce brightly-coloured opaque glass tesserae.

Spatula A plastic, wooden or metal tool used for mixing and spreading grout.

Tertiary colour Produced by mixing primary and secondary colours, i.e. crimson, violet-blue, turquoise, lime, orange-yellow, orange-red.

Tessera (plural tesserae) Originally used to describe a cube of stone, marble, glass or terracotta used in mosaic-making. The term is now used to refer to any objects used, for example, pebbles, shells and beads.

Tone This describes the lightness or darkness of a colour. On a colour wheel yellow is usually the lightest tone and violet the darkest.

Vitreous glass Purpose-made mosaic glass tesserae. The range of colours is not as great as smalti, but they are cheaper and easier to use. The tesserae usually come on sheets with the flat side uppermost and the lower, ridged side lightly glued to the paper.

Warm colours The right-hand side of the colour wheel, usually reds and oranges. Warm colours have a tendency to advance or stand out in a design.

Useful information

Books of interest

Roman Art and Architecture: M. Wheeler. Thames and Hudson

Ancient Mosaics: R. Ling. British Museum

The Art of Mosaics: ed. C. Bertelli. Cassell

Decorative Floors of Venice: T. Sammartini. Merrell

Traditional Islamic Craft in Moroccan Architecture: A. Paccard. Editions Atelier

Antonio Gaudi: R. Zerbst. Taschen

The Grammar of Ornament 1856 (and many later editions.) Day & Sons

The Oxford Companion to Art. OUP.

Micromosaics: The Gilbert Collection: J. H. Gabriel. Philip Wilson.

The Art of Pebble Mosaics: M. Howarth. Search Press

The Ten Books on Architecture: Vitruvius. Dover

Dover Books specialize in patterns of all types, many of which are suitable for mosaics.

Places of interest

This is not intended to be a comprehensive list of all mosaic sites, but is simply a brief selection. Not all mosaic sites are listed within each city and it is recommended that you always consult a local guide book. Also always keep a look out for buildings such as town halls, many of which use mosaics in their facades.

UK

- British Museum, London
- Victoria and Albert Museum, London
- Fishbourne Roman Palace, Sussex
- St Paul's Cathedral, London
- The Albert Memorial, London
- The Tate Gallery (Floor by Boris Anrep), London
- Cirencester, Gloucestershire
- Halstock, Dorset
- Aldborough Roman Town, Yorkshire
- Gilbert Collection, Somerset House, London

France

- The Louvre, Paris
- Unesco House, Paris
- Opera, Paris
- Tomb of Rudolf Nureyev, Russian cemetery, St Genevieve Sous Bois, Paris
- Musee de Ferdinand Leger, Biot, Alpes Maritimes

Italy

- Herculaneum
- Pompeii
- Ravenna (churches and museum)
- Basilica and Museum of Archaeology, Aquileia
- Venice (especially cathedral of San Marco and Island of Murano)
- Chapel of San Aquilano, Milan
- San Prassede, Rome
- San Clemente, Rome

- Cathedral of Mon Reale, Sicily
- National Museum, Naples
- Vatican Museum, Rome
- Ostia

Spain

- Cordoba – especially the mosque
- Ampurias
- Barcelona – especially Sagrada Familia and Parc Guell

Portugal

- Conimbrega, near Coimbra

Germany

- Rheinsiches Landesmuseum, Trier
- Berlin State Museum, Berlin

Greece

- Pella, Macedonia
- Corinth (site and museum)
- Island of Delos
- Churches of St George and Hosios David, Thessalonika

Sweden

- Stockholm City Hall

Russia

- Cathedral of St Isaac, St Petersburg
- Church of San Sophia, Kiev

Cyprus

- Paphos

Egypt

- St Catherine's Monastery, Mt Sinai
- Graeco-Roman Museum, Alexandria
- National Museum, Cairo

Turkey

- Villa of Constantine, Antioch
- Hagia Sophia, Istanbul
- Great Palace Mosaic Museum, Istanbul

Tunisia

- Bardo Museum, Tunis
- El Djem (museum and site)

Morocco

- Site of Volubilis near Moulay Idris

Jordan

- Madaba (site and museum)
- Mount Nebo (site and museum)
- Jerash (site and museum)

Israel/Palestine

- Dome of the Rock Mosque, Jerusalem
- Khirbet-el-Mafjar, Jericho
- Synagogue Gaza

Lebanon

- Biet el Din Palace, near Beirut

Libya

- Zliten, Roman Villa

Syria

- Great Mosque, Damascus

Iran

- Shah Mosque, Isfahan

Mexico

- National Museum of Anthropology: Mexico City

USA

- Dunbarton Oaks Research collection and Library Washington DC

Suppliers

A great deal of the equipment needed to make mosaics can be bought in non-specialist shops. Charity shops, jumble sales and boot fairs are good sources for cheap and interesting china. Many tile shops will sell cheaply or even give away old samples or surplus tiles. Timber merchants will usually cut wood to your requirements and hardware shops and builders' merchants will supply much of the rest that you need. These last are most important as they will be able to offer you advice on the particular products – each mosaic has different requirements and even though the staff may not be used to making mosaics they will know exactly what their products are capable of. Inexpensive furniture shops, such as Ikea, are a good source for bases.

Specialist suppliers

UK

- Reed Harris Ltd, Riverside House, Carnwath Road, London SW6 3HR
- Edgar Udney & Co Ltd, The Mosaic Centre, 314 Balham High Street, London SW17 7AA
- Paul Fricker, Well Park, Willeys Avenue, Exeter EX2 8BE (Mail Order)
- James Hetley & Co Ltd, Glasshouse Fields, Schoolhouse Lane, London E1W 3JA
- Tower Ceramics, 91 Parkway, Camden Town, London NW1 9PP
- Fred Aldous, PO Box 135, 37 Lever Street, Manchester M60 1UX
- Specialist Crafts Ltd, PO Box 247, Leicester LE1 9QS (Mail Order)
- Homecrafts Direct, PO Box 38, Leicester LE1 9BU (Mail Order)
- The Mosaic Workshop, Unit B, 443-9 Holloway Road, London N7 6LJ *and* also at 1a Princeton Street, London WC1R 4AX
- Color 1 Ceramica, 404 Richmond Road, East Twickenham, TW1 2EB
- Harvey Baker Design Ltd, Rodgers Industrial Estate, Yalberton Road, Paignton, Devon TQ4 7PJ (MDF Blanks)

Italy

- Mosaica Dona Murano di Dona Stefano, Fondamenta Venier 38a, 30141 Murano
- Mario Dona e Figli Snc, Via Marchetta Guiseppi, 4-6 Zona Artigianale, 1-33097 Spilimbergo (PN)
- Orsoni, Cannaregio 1045, 30121 Venezia
- Ferrari e Bacci Snc, Via Aurelia 14, 55045 Pietrasanta (Lu), Toscania

France

- Opio Colours, 4 Route de Cannes, 06650 Opio

Canada

- Interstyle Ceramic & Glass Ltd, 8051 Enterprise Street, Burnaby, Vancouver BC, Canada V5A 1V5.

Australia

- Camden Arts Centre Pty Ltd, 188-200 Gertrude Street, Fitzroy 3065
- W M Crosby (Merchandise) Pty Ltd, 266-274 King Street, Melbourne 3000
- Rodda Pty Ltd, 62 Beach Street, Port Melbourne, Victoria
- Alan Patrick Pty Ltd, 11 Agnes Street, Joliment, Victoria 3002
- Glass Craft Australia, 54-56 Lexton Road, Box Hill North, Victoria 3129

South Africa

- Art, Craft and Hobbies, 72 Hibernia Street, George 6530
- Crafty Suppliers, 32 Main Road, Claremont
- South Arts and Crafts, 105 Main Street, Rosettenville

USA

- Mountaintop Mosaics, Elm Street, PO Box 653, Castleton, VT 05719
- Mosaic Mercantile, Modern Options Inc, 2831 Merced Street, San Leandro, CA 94577
- Ideal Tile of Manhattan Inc, 405 East 51st Street, NY, NY 10022
- Eastern Art Glass, PO Box 341, Wyckoff, NJ 07481
- Stroke of Genius, 2326 Fillmore Street, San Francisco, CA 94115

Mexico

- Mosaicos Venecianos de Mexico SA de CV, Carretera Federal, Cuernavaca-Cuautla, 62570 Cuernavaca

New Zealand

- Handcraft Supplies Ltd, 13-19 Rosebank Road, Avondale
- New Zealand Hobby, Clay and Craft Co Ltd, 1/80 James Fletcher Drive, Mangere
- The Tile Company, 782 Great South Road, Penrose

Internet

Many mosaic suppliers have their own websites which can be useful for research even if you do not buy via the internet. Also new products are always being developed and most shop sites on the internet are regularly updated, for example, quarter size vitreous glass tesserae from Mexico are now available. For detailed work they save a lot of fiddly cutting but, perhaps more importantly, they are available in an unusual range of colours.

The following are a small selection of sites which have examples and ideas as well as just products. Using a Search engine will obviously produce many more.

- http://www.asm.dircon.co.uk
- http://www.mendels.com
- http://www.mountaintopmosaics.com
- http://www.mosaicartdirect.com

Index

Adhesives 4, 17–18, 25–29
Alexandria 83
Ancient Mosaics 79–93
Asaroton 86–87

Bases: preparation 20–23
 types 19–24
Bookends project 72–73
Books of Interest 110
Buttering 18, 108
Byzantine Mosaics 7,
 79–80, 88–90

Cement 22, 27, 108
Cement-based adhesive
 18, 26–27, 108
Cement-based grout 18,
 30–31
Ceramic mosaic tiles 9,
 62–63, 108
Chessboard project 62–63
Cinca 9
Cleaning 18, 35–36
Colour theory 99–102
Cosmati work 108
Crockery 5, 9–11, 52–53,
 58–61, 64–65, 76–77
Cutting: methods 9
 tools 16–17

Design 15–16, 20, 94–107
Desktop project 46–47
Direct method: meshbase
 38-39, 66–67
 projects 45–61, 64–77

techniques 33–9
3-D object 37–8, 45,
 48–49, 70–73

Egyptian Mosaics 82–83
Emblema 85, 108
Environment viii, 12
Epoxy resin adhesive 18,
 26, 108
Epoxy resin grout 31
Equipment 15–18
EVA 26
Exterior mosaics 22, 60–61

Filati 107, 108
Firescreen project 52–53

Gaudi, Antonio 92–93
Glass tesserae 5–9, 46–47,
 49, 54–55, 58–59,
 66–67, 72–77
Glues 17–18
Goggles 15
Gold tesserae 7, 66–67,
 80, 83, 85, 89
Greek mosaics 79–85
Grouts 4, 18, 30–31, 108
Gum Arabic 28

Hagia Sophia 88–89
Hammer & Hardie 17
History 6–7, 40, 78–93
Holder project 64–65

Household Tiles 10, 50–53,
 56–57, 60–61, 68–71,
 76–77

Indirect method: project
 62–63
 techniques 40–43

Jewellery box project 48

Klimt 91–92

Lamp project 49
Letter rack project 45
Lighting 4

Marble 12
MDF 19–20, 109
Mesh 19, 23, 38–39, 66–67
Mesopotamia 80
Metal 24
Mexican mosaics 91, 97
Micromosaics 7, 91, 109
Mirror project 58–59
Mirrored tesserae 12,
 72–73
Mosaic cutters 16–17
Museums 110–111

Nippers 16–17

Opus musivum 86, 105,
 109
Opus regulatum 86, 104,
 109

Opus romanum 109
Opus sectile 86, 109
Opus tessellatum 86, 104,
 109
Opus vermiculatum 86,
 104, 109
Ostia 86
Outdoor mosaics 22, 60–61

Paper 13, 24
Paving slab 42–43
Pebbles 11, 52–53, 80
Pella 81
Pen holder project 45
Pizza 6,109
Placemat project 74–75
Planter project 60–61
Plaque project 76–77
Plaster 23
Plywood 19–22, 109
Pompeii 83
Pre-Columbian mosaics 79,
 90–91
PVA 16, 20, 25–26, 109

Quantities of tesserae 13

Ravenna 89
Religious mosaics 88–90
Renaissance mosaics 79,
 91
Roman mosaics 79, 83–89

Safety viii
Sandbox 42–43
Sealing: bases 20–23
 mosaics 18
Seif-grouting technique
 36–37
Semi-precious stones 12
Shells 11, 45, 52–53,
 58–59
Silicone adhesive 27–28
Silver tesserae 7

Smalti 6–7,48,109
Smalti filati 7, 109
Splashback project 68–69
Stone 12, 22
Storage 3–4
Sumer 80

Tabletop project 50–51
Techniques 33–43
Terracotta 10, 20–22,
 60–61

Tessera: cutting 9, 16–17
 types 5–13, 109
Tile backer board 24
Tools 15–18
Tray project 54–55

Unswept floor mosaic
 86–87

Vase project 70–71
Venice 66, 89, 91

Vitreous glass tesserae 7–9,
 46–47, 54–55, 58–59,
 66–67, 74–75, 109
Vitruvius 83

Wallpaper paste 28
Wastepaper basket project
 56–57
Wood 19–22
Workspace 3–4